Athena and Kain

The True Meaning of Greek Myth

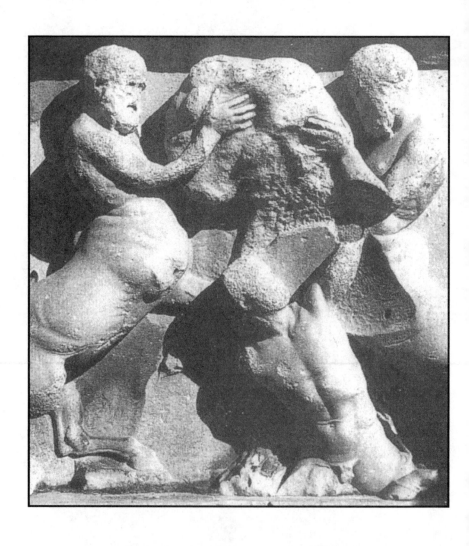

Kentaurs Pound Kaineus into the Ground with a Boulder.
West Frieze of the Temple of Hephaistos, Athens.

Athena and Kain
The True Meaning of Greek Myth

Robert Bowie Johnson, Jr.

SOLVING LIGHT BOOKS

©2003 Robert Bowie Johnson, Jr.
Solving Light Books
727 Mount Alban Drive
Annapolis, Maryland 21401

solvinglight.com

ISBN 0-9705438-2-4

Cover Illustration:

Kalyx krater with Athena, Gaia, and Erichthonios. Richmond, Virginia Museum of Fine Arts, The Arthur and Margaret Glasgow Fund, inv. No. 81.70.

All Scripture passages, unless otherwise noted, are from the Concordant Translation, Concordant Publishing Concern, Santa Clarita, CA 91387 (Concordant.org).

Material from the Perseus Library, noted in the photo credits, is copyrighted by the Corporation for Public Broadcasting and the President and Fellows of Harvard College.

Thanks to:

The Perseus Library, and all those who have written detailed descriptions of vase-paintings and sculpture for it including Deirdre Beyer-Honça, Nick Cahill, Suzanne Heim, Kathleen Krattenmaker, Anne Leinster, and Beth McIntosh.

Ellen D. Reeder and all of the other scholars who contributed to her marvelous book, *Pandora: Women in Classical Greece.*

Thanks also to:

Ron Pramschufer, Nancy Beth Johnson, Ric and Patsy Davis, Nathan Steele, Peter Lord, John Gautier, Jay and Peggy Joseph, Peggy Griggs, Mark Wadsworth, Frank Bonarrigo, Richard Burt, Don MacMurray, Michael Thompson, and Richard Elms.

And special thanks to:

Dean H. Hough and James R. Coram, co-editors of *Unsearchable Riches*, a publication of the Concordant Publishing Concern. I appreciate their enlightening and inspired writings. I have used some of Mr. Hough's words freely in Chapter 4, "The Way of Kain."

For the many students who will soon be
teaching their teachers.

Contents

Contents

Preface

The content of this book is revolutionary. I suggest you begin by flipping through and reading the summary at the beginning of each chapter. That will give you a good overview and a sense of where the theme is headed.

Athena and Kain is based on a simple premise: if the Book of Genesis is true, then those truths in Genesis which pertain to humanity as a whole (Eden, the Flood, the Tower of Babel) must be recorded in the "myths" of the dominant ancient Greek Mediterranean culture. If we are all part of the same human race, with the same origin as described in Genesis, this has to be the case. Proceeding on this premise, and relying on the work of meticulous scholars, solid evidence, and common sense, we find that the Greek myths tell the same story as the early chapters of the Book of Genesis, except from the point of view that the serpent is the enlightener of mankind rather than its deceiver. The evidence substantiates the premise: the Judeo-Christian and Greek religious traditions parallel each other, and both record the true history of humanity, yet from opposite standpoints.

Without the Book of Genesis as a guide, Greek vase-paintings and sculptures present us with an amalgam of ambiguous elements whose meaning we cannot satisfactorily discern. But with Genesis as a frame of reference, ancient Greek art begins to make sense to us. No longer trapped in a fuzzy mental realm full of perplexing gods and befuddling stories, we begin to see the remarkably clear and coherent messages painted on vases and carved in marble by our ancestors. The best part comes when you see that this new understanding is not so much profound as it is obvious.

Kain, Kaineus, and Kentaurs

Why Kain instead of Cain? The Greek Scriptures (Matthew to Revelation) were originally written in uppercase Greek. The name of the man, Kain, written as "KAIN," appears three times (Hebrews 11:4, I John 3:12, and Jude 11). On the François vase from the 6th century BC, a cer-

vii

tain man being pounded into the ground by Kentaurs is identified as "KAINEUS." As we shall see in Chapter 7, both names refer to the same man. Keeping the original spelling helps maintain a connection that is essential to understanding the basic truth of ancient Greek religion: it chronicles the reestablishment of the way of Kain after the Flood.

I don't know why the King James scholars translated KAIN as Cain, or why Robert Graves translated KAINEUS as Caeneus, but both translations tend to disguise the fact that the ancient names represent the same person.

The Greek word usually translated as "centaur" is *Kentauros.* In a very significant Greek myth, Kentaurs, half-men/half-horses, kill some ancient Lapiths (Flint-chippers) and carry off their women (Chapter 6). Scholars capitalize Lapith because it represents a specific group of people. They think of the half-men/half-horses, however, as strange animals who represent barbarianism, and so they use the lowercase "centaur." The truth is that the Kentaurs represent what the Greeks considered to be a "strange branch" of humanity—the line of Seth, the offspring of Adam's and Eve's youngest son. Thus, as the name of a particular group, it should be capitalized, and to emphasize that fact, I keep the original Kappa, or K; therefore, Kentaur.

One more thing. To really understand this, you'll need to think like the ancient Greeks. If you don't realize it now, by the time you're finished reading the introduction, you'll be happy to find out that in many ways you *already* think like the ancient Greeks.

ntroduction

In the preface to *Athena and Eden*, I quoted great historians, scholars, and historical figures in order to impress upon the reader the importance and power of Greek culture. This introduction, which serves the same purpose as that preface, is more down-to-earth.

Every day, ancient Greek men and women came into contact with the myths that told the story of their origins. They saw them sculpted on public temples, painted on walls in the marketplace, painted on pottery used for eating and drinking, on cosmetics boxes, and on storage jars for water, olive oil, wine, and other comestibles. These myths were part of their everyday life.

In many ways each day, we mechanically think and act like our ancient Greek forebears. That is the first point of this introduction. The second point is that where they came from is where we came from. That's why their "myths" should be an integral part of our lives as well.

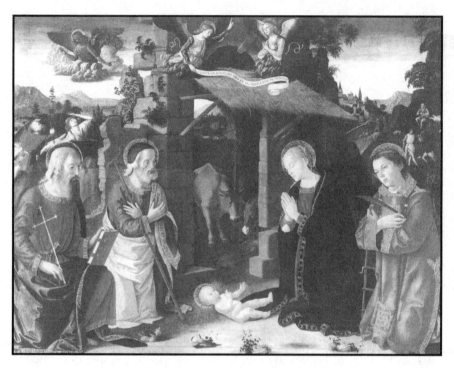

We recognize the above scene right away. It's the Nativity—the birth of Christ. You don't have to be a Christian to recognize it. Jews recognize it. Agnostics recognize it. Atheists recognize it. This latter group must know what it means because some of them are so offended by it when it appears on public property, they demand its immediate removal. Most Westerners can look at this painting and tell you Who the Child is, where He was born, when He was born, why He was born, who His parents were, and what this Child's birth means to them.

It's a different story with the image on the adjacent page, enlarged and in color on the cover. It's a Greek painting from about 410 BC, depicting a very special birth that took place in Athens in about 1400 BC. I doubt if one out of a hundred thousand Westerners could tell us who this child is, when he was born, where he was born, or why. The idea that this child's birth would mean anything to them is thus out of the question. Our failure to recognize this birth and its meaning represents a blind spot for all thinking Christians and non-Christians alike.

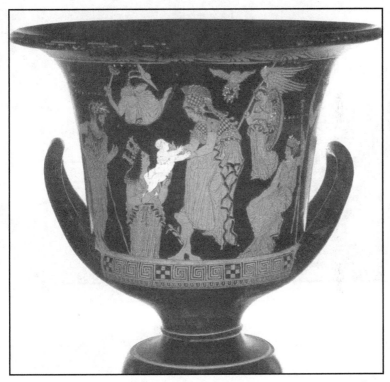

Just as you understand the Nativity scene, so should you understand the meaning of the above birth scene. Once you've read this book you will understand it. In fact, we could say that the goal of this book is to help you understand this one scene, because if you grasp what the vase artist is telling us, you grasp the essence of Greek mythology. That is a very exciting prospect.

The container itself is a red figure kalyx krater that stands 37.9 centimeters high. The Greeks mixed their wine with water, and that is what this kalyx krater was used for. The body of the vessel looks like the calyx (or bud sheath) of a flower, hence its name.

The red figure technique used the rich red of the clay for the figures with a painted black background. The artist is known as the Nikias painter. In his *Athenian Red Figure Vases: The Classical Period*, Sir John Boardman writes that this artist "is named for the potter who signed himself Nikias, son of Hermokles."

Let's think about the influence of the ancient Greeks on our lives and culture. Our universities and other academic institutions are based on the Academy of Plato. His real name was Aristokles, but they called him Plato, which means "broad" in Greek, because of his broad shoulders. Plato's writings, almost all of which survive, are very broad in their scope, encompassing most of the subjects humans have thought about.

Plato founded his Academy in 387 BC in a grove which was part of the land that belonged to Akademos on the edge of Athens. Devoted to research and instruction in philosophy and the sciences, Plato presided over his Academy until his death. After his death, the Academy continued to flourished for over 900 years. In 529 AD, the Christian Emperor Justinian attacked it as a pagan institution and shut it down.

Plato, Aristotle, and many other Greeks established the grooves of our intellectual habits. Those who browse through the meadows of knowledge will find most of the acreage originally planted in ancient Greece.

4

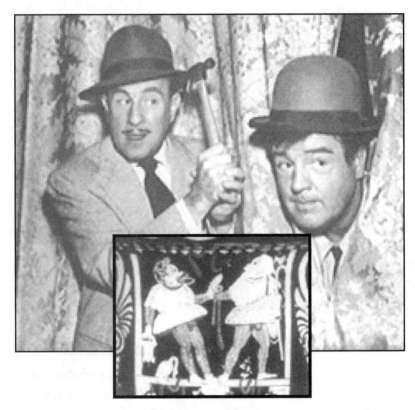

Ancient Greek comedy means something to us, because as Abbott and Costello would tell us, it's the basis of our own comedy. On the inset vase depiction from ca. 330 BC, two comic actors ham it up on an elevated stage.

The Greek playwright, Aristophanes (ca. 450 - 385 BC), is all but unrivalled in the invention of comic situations: in parody, in satire, in wit, and in downright farce. When we watch funny movies or television situation comedies, that's what we still want—parody, satire, wit, and farce. In many of Aristophanes' farcical scenes, a main personage of the play puts up with odd associates and puts to flight unwelcome visitors. Isn't that the plot of just about every *Seinfeld* episode?

The ancient Greeks were also into comic word play. By the way, I meant to tell you that our dental hygienist retired after twenty years on the job. Do you know what they gave her in recognition? A little plaque!

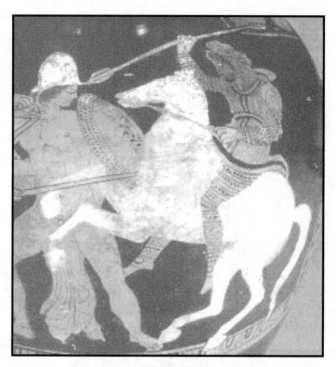

On the above vase-painting from the late Classical period, a youthful Greek advances against a bearded Persian cavalryman. At Marathon, in 490 BC, the Greeks defeated a Persian army five times its number from an empire a hundred times its size. The Greeks suffered 192 dead, while killing 6,400 of the Persian horde whose western advance was stopped for the first time.

We understand the need to be prepared for war, but sometimes we forget how much we owe to ancient Greek soldiers. We should remember the hardships they and their families endured. Without the Greek victories at Marathon and Salamis who knows what kind of religious and political values we'd be living under and fighting for today? So it's not simply ancient Greek ideals that have made our culture what it is, but the shedding of Greek blood in opposition to totalitarianism as well.

The battle between the open and the closed society is still very much a part of our world. It's the flowering of the fruit of Greek culture that today's madmen and terrorists hate.

The brilliant *Dilbert* cartoonist, Scott Adams, has been kind enough to put the general public's superficial knowledge of ancient Greece into the mouth of his galling and dauntless character, Wally, without my even asking. Adams' Web Site, Dilbert.com, describes Wally's personality this way: "Dilbert's colleague and fellow engineer is a thoroughly cynical employee who has no sense of company loyalty and feels no need to mask his poor performance or his total lack of respect." You don't want to be like Wally, do you? Okay then, enjoy this book and absorb what it has to tell you. Then, if you do work in an office, send memos to your subordinates, colleagues, and superiors that say simply, "I understand what the ancient Greeks were trying to tell us in their myths," and see what kind of reaction you get.

Wally may be a loser, but I suppose a little superficial knowledge is better than abject ignorance. In her book, *The Parthenon*, Mary Beard reports this verbal exchange:

> **Reporter: "Did you visit the Parthenon during your trip to Greece?"**
> **Shaquille O'Neal (US basketball star): "I can't really remember the names of the clubs we went to."**

Who is responsible for this widespread abysmal incomprehension of our cultural heritage? Victor Davis Hanson and John Heath, authors of *Who Killed Homer?,* believe that the culprits are lazy, irresponsible academics. In their book, they "make no apologies for adapting a populist stance, for attacking the narcissism and self-congratulatory posture of these self-described 'theorists' who [offer] very little for a very few and nothing for everyone else." I agree with Hanson and Heath.

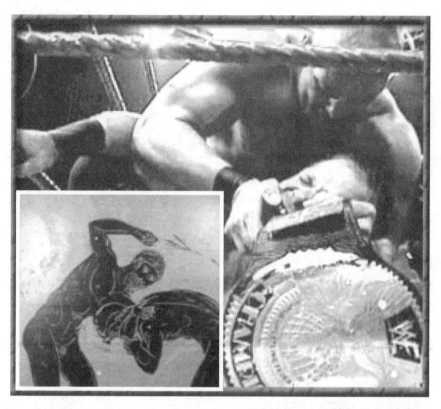

The inset, above, is part of a vase-painting from ca. 332 BC. Two nude opponents engage in *pankration*. The one to our left has wrapped his left arm around his opponent's face, and his right hand is raised to deliver a punch, while his opponent bends forward, trying to pull away the arm squeezing his face. This is how the *Oxford Classical Dictionary* describes the ancient Greek sport of pankration: "You might kick your opponent in the stomach; you might twist his foot out of its socket; you might break his fingers. All neck holds were allowed, the favorite method being the 'ladder grip,' in which you mounted your opponent's back, and wound your legs round his stomach, your arms round his neck." If this isn't a near-precise description of today's World Wrestling Entertainment, Inc.'s smackdowns, what is it? How many millions follow the antics of the WWE today, unconscious of how Greek the belligerent bruisers are, and how Greek they themselves are as spectators?

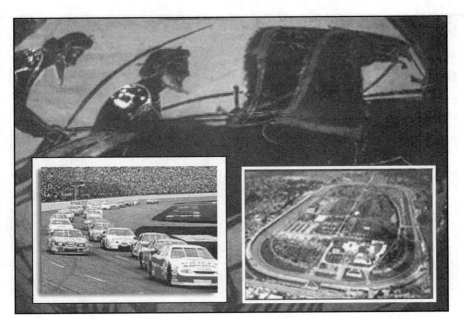

We know that the NASCAR races in Indy, Dover, Daytona and elsewhere find their roots in the chariot races in ancient Olympia around 800 BC. It's still horsepower that matters.

This page is for the many enthusiastic fans of NASCAR, especially one particular friend who is an avid follower of car racing but who told me quite frankly that he wasn't interested in "all that Greek stuff." Surely, my friend, you see by now that "that Greek stuff" is what you live for on the weekends. In a way, you are a puppet, and the ancient Greeks who invented chariot racing are your puppet masters, still pulling those strings across time and space.

You are already enjoying a great Greek sport. Now take the next step and understand its relationship to the history of the human race. Read Chapter 17 which deals with the very first chariot races. The next time you are at the track and there is an extended yellow flag, beguile the tedium by telling the race fans around you how the competition started as a life-and-death race back in Olympia, with great wealth and a gorgeous woman as the prize. Then, if your friends are impressed, urge them to buy my book, please.

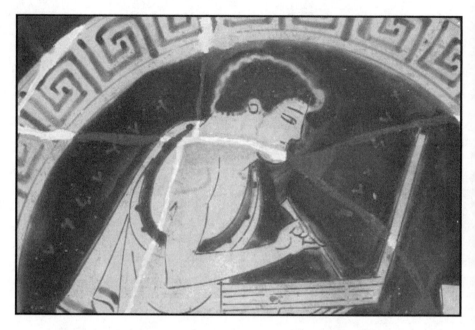

On the interior of a drinking cup, above, from ca. 480 BC, a young Greek man gingerly holds a stylus which he is using to write on the folding tablet on his lap. It looks like he's using a laptop computer. If it weren't for the Greeks' curiosity and their love of mathematics and science, we wouldn't have computers. As far as the development of technology (from *techne* = craft in work, especially metal-working, and *logos* = logic; thus the logic of a craft) is concerned, we are simply putting the flesh on the Greek skeleton (from the Greek *skeleton*, dried body).

Our scientific terms are based almost exclusively on Greek words. Here are just a few of them: electricity, electron, atom, physics, astrophysics, biology, thermodynamics, geometry, archeology, and psychology (from *psyche* = soul and *logos* = logic; hence the logic of the soul).

The books from Matthew to Revelation were originally written in Greek. In II Timothy 3:16 we read that "All Scripture is inspired by God." If that is true, then we can say with certainty that the Supreme Creator of all things chose ancient Greek, a language of great clarity and precise structure, to communicate with his human creations. Isn't that reason enough to familiarize yourself with the ancient Greeks?

The Greeks' prodigious boldness and energy of intellect vastly extended the vision of human opportunity. In *Who Killed Homer?*, Hansen and Heath write:

The internet, and the whole electronic revolution, is merely a logical cultural consequence of the Greeks' legacy of open inquiry, self-criticism, anti-aristocratic thought, free expression and commerce, and their faith in disinterested reason and science, immune from the edicts of general, priest, and king.

They add:

Strange it is, then, that the Greeks who started it all off are so little known in modern America.

And I add that it is stranger still that we treat what was most important to the Greeks—their religion—as if it were a collection of fairy tales, when in fact it is one side of our own spiritual history.

The ancient Greeks' religion found expression in their prayers, their sacrifices, their temples, their sculpture, their paintings, their myths, their coinage, their politics, their festivals, and just about every other aspect of their society. But yet today, we don't understand what their religion meant to them at all.

If we are to understand Greek religion as it is expressed in Greek art, we must approach it with a sense of wonder; and I don't mean wonder in the sense of mindless awe. I mean wonder in the sense of this dictionary definition: "To feel doubt and curiosity, to query in the mind, to want to know." We need to be skeptical about what we've been taught about it, and curious as to its true meaning. Let's call this combination of skepticism and curiosity, "skeptiosity." With this approach, and given enough

information, time, and insight, we can understand what the great Greek myths, previously misunderstood, really mean. Let's jump out of those dead-end mental ruts, and start thinking with an alacrity worthy of our Greek ancestors.

Rote regurgitation, not skeptiosity, is what rules in many fields today. Let me give you a real life example of skeptiosity meeting regurgitation head on. Recently, my wife and a friend and I attended a lecture in Washington, DC, sponsored by an archeological society. The speaker, a well-known authority on the history of the Parthenon sculptures, presented a number of slides pertaining to her theme including one which depicted Kekrops as on this page.

During the question period, a college student asked the lecturer why the Greek artist depicted this man as a serpent from the waist down. An excellent question. With skeptiosity, there's an intuition that there's something here we don't understand that is well worth understanding. If you have read *Athena and Eden*, you know Kekrops is the king who established Zeus-religion in Athens, and that he is depicted as half-man/half-serpent because he represents the serpent's man. Skeptiosity clears a befogged intellect, and enables the truth-seeker to follow the straight-forward path of inexorable logic.

But what was the lecturer's reply to this student's skeptiosity? She said, "He's part serpent because there were a lot of snakes on the Akropolis back then, and there still are." Adopting this kind of thinking, we should expect to find half-men/half-rats depicted somewhere in Greek art as well because there were rats on the Akropolis back then, too. What an explicit slur upon the mentality of the ancient Greek artists, by the way! The lecturer had not properly digested this material herself. Rather than regurgitate, she should have said simply, "That's a good question. I don't know the answer. Any thoughts from the audience?"

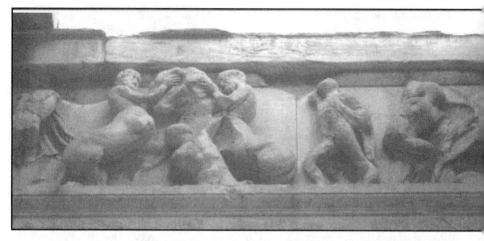

Above, we see two Kentaurs, half-men/half-horses, pounding a man into the ground with a boulder. Who is this man to the Greeks? Why would Greek artists spend years of work sculpting such a scene?

Greek artists sculpted Kentaurs on the temple of Poseidon south of Athens, on the temple of Apollo at Bassae, on Athena's temple—the Parthenon, on the temple of Zeus at Olympia, and on many other temples including the west frieze of the temple of Hephaistos in Athens, pictured in part, above. Kentaurs appear often on Greek vase paintings.

The standard explanation is that the battle between Greeks and Kentaurs represents the struggle between civilization and barbarism. While there is a grain of truth in this, the facts just don't fit into such a general theory. Why, if Kentaurs represent barbaric men, is the Kentaur Chiron highly regarded as the tutor of the famous warrior Achilles? Consider this: eighteen of the thirty-two metopes on the south side of the Parthenon depicted Kentaurs fighting men; and while the battle appears even on four of the metopes, on at least ten of them, the Kentaurs are defeating the men. Why would a temple designed, in part, to showcase the glory of Athens, feature a defeat at the hands of barbarians? And what about the scene above?

We'll need to generously engage our skeptiosity in order to grasp what the Greeks were trying to tell us through their ubiquitous depictions of these strange creatures.

Many of the Greeks' religious images seem bizarre and inexplicable. Above, we see a worshipper placing a statue of Hermes with an erect phallus near an altar. Why was he doing this? What did it mean to him? We'll see in Chapter 12 that these "Herms" were central to Greek religion. Many scholars have referred to scenes such as these as "ithyphallic." I have found that when I run into a word like this, the person who used it has run into a brick wall—he or she simply can't figure out what a certain depiction means.

Another word in the same class is "chthonian." It means "under the earth," and scholars use it when they don't understand a scene involving an earth-born child or deity. I may not understand the scene either, but I'm not going to further obfuscate its message by calling it "chthonian."

Another more often used word is "archtypical." Literally it means "pertaining to the origin-type," and in many cases it is used to make the writer's ignorance of certain origins seem just the opposite. Calling the above image an ithyphallic, chthonian, archtypical figure might make me seem smart, but it adds nothing to our understanding. Don't worry, I'm not going to use these three words again in this book.

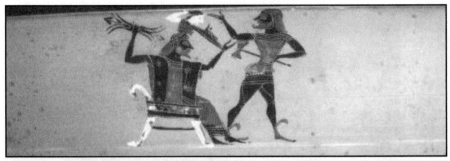

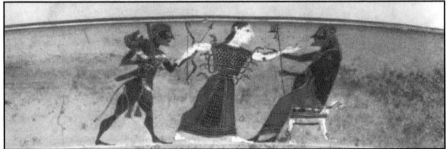

On one side of this large drinking cup, the Greek artist depicted Zeus on his throne with Athena being born full-grown out of his head, as Hephaistos, with his axe, steps away. On the other side, the artist depicted Athena introducing the immortal Herakles to Zeus on Mount Olympus. The Greeks understood what each scene meant, and they grasped the integral relationship between them. By the time you're half-way finished reading this book, you'll be able to come back to this page and understand what the two paintings mean, and see the connection.

In *Athens and the Greek Miracle*, C. P. Rodocanachi wrote, "No civilization may be understood without reference to the religion of those who built it." The Greeks built the foundations of Western Civilization. Without comprehending the significance of their religion, we can't really understand who they were, and what they thought of themselves. And without understanding them, we can't truly understand ourselves and the cultural framework of the times in which we live.

Let's take a look at the main characters in this book, and then begin our quest for understanding at the beginning in Eden, where the Greek religious system originated.

Chapter 1
Identities of the Main Greek Characters

Greek gods and other legendary figures look like humans be-cause they are our human ancestors elevated to divine or semi-divine status relative to their places in the Greek religious system.

This chapter is meant to help you learn their true identities quickly. Refer back here any time.

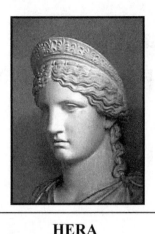

HERA
The sister/wife of Zeus
and the mother of all is
EVE
The sister/wife of Adam
and the mother of all living

ZEUS
The father of gods and men is
ADAM
The father of humanity

HEPHAISTOS
Eldest son of Zeus and Hera is
KAIN
Eldest son of Adam and Eve

ARES
Youngest son of Zeus and Hera is
SETH
Youngest son of Adam and Eve

APHRODITE
is the sister/wife of
Hephaistos, and the sister
and sometime lover of
Ares.
She represents
THE WIFE OF KAIN

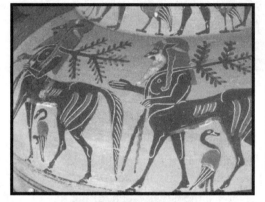

KENTAURS
are half-men/half-horses
who, to the Greeks, repre-
sent that strange branch of
humanity . . .
THE LINE OF SETH

NEREUS
is the "Wet One" and the
"Salt Sea Old Man." He is
NOAH

NEREÏDS

are the fifty daughters of Nereus. They are the

DAUGHTERS OF NOAH

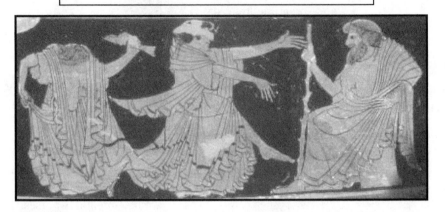

POSEIDON

with his trident. This "brother" of Zeus takes the place of Nereus by marrying his daughter, the Nereïd Amphitrite. Nereus, the Greek Noah, of the line of Seth, can have no power in the Greek system, and so Poseidon becomes

GOD OF THE SEA'S POWER

AMPHITRITE

A daughter of Nereus, or Noah, taken to wife by Poseidon. Thus the family of Nereus becomes his. Identified with dolphins, she is a simple personification of the sea, and

GODDESS OF THE CALM SEA

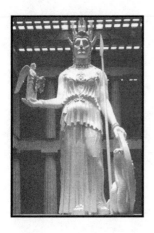

ATHENA
is the goddess of the serpent's wisdom. Born full-grown out of Zeus in Hera's presence, she represents the reborn
SERPENT'S EVE
after the Flood

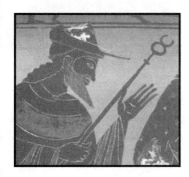

HERMES
is the chief prophet of Zeus-religion, and leader of the rebellion in Babylon. The son of Ham, grandson of Noah, and the true father of Nimrod, or Herakles, he is
CUSH

HERAKLES
is the mighty hunter and conqueror named in Genesis
NIMROD
transplanted to Greek soil.

Chapter 2
The First Couple

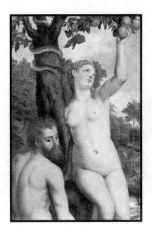

There is no Creator-God in the Greek religious system. Their understanding of human origins begins with the first couple, Adam and Eve whom they call Zeus and Hera.

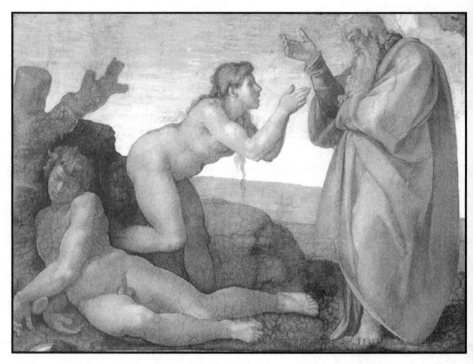

In the Book of Genesis, there is a Creator-God. The very first fact asserted in the ancient scrolls is this: "Created by God (Elohim) were the heavens and the earth." Although the Scriptures say that God is an all-powerful, omnipresent, invisible Spirit that no man has ever seen, Michelangelo depicts Him as a mature man, above bringing Eve to life full-grown out of Adam. The Scriptures describe the Creator as Spirit, Light, and Love. In Isaiah 45:7, He takes exclusive responsibility for everything: "I am Yahweh Elohim, and there is none else. Former of light and Creator of darkness, Maker of good and Creator of evil. I, Yahweh Elohim, made all of these things."

The ancient Greek religious system is about getting away from the God of Genesis. I was struck when I read this simple sentence which begins Chapter 3 of mythologist Carl Kerényi's book, *Prometheus*: "Greek mythology knows of no creator of the world." This is an obvious and stark contrast to the viewpoint expressed in what the apostle Paul referred to as the "Sacred Scriptures."

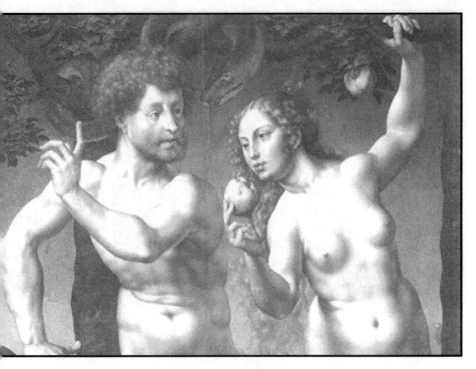

In the Greek religious system, the Creator, visible or invisible, has no place in the picture, as in Jan Gossaert's painting, above. The serpent takes His place. The Greek gods looked exactly like humans because, for the most part, they were the Greeks' deified human ancestors. Zeus and Hera were the many-generations-removed source of their own Greek flesh. Zeus' and Hera's association with the beginning of things, as the first couple, gave them their stature as the supreme gods. What the Greeks knew of these beings was part of their collective cultural memory, passed down as oral tradition through the family of Noah at first, and then through their own poets and artists.

Zeus and Hera, and the other gods who ruled over the Greek will and destiny, were their own progenitors, deified in the persons of those original and great beings whom they honored and worshipped. Thus the will of the gods was in reality the will of their own human family. In the Greek system, Adam and Eve ruled over their posterity with divine honors as Zeus and Hera.

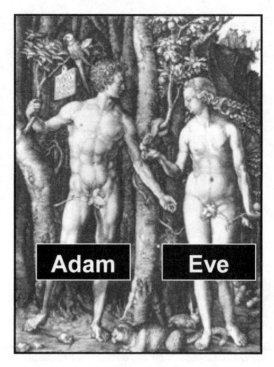

Above, we see *Adam and Eve* by Albrecht Dürer. This is the begin-ning of the family of man, and the origin of the family of the Greek gods, Zeus and Hera. According to the Book of Genesis, Eve is the mother of all living humans, and the sister and wife of Adam. Correspondingly, in Greek myth, Hera is the goddess of childbirth, the sister and wife of Zeus, and the goddess of marriage.

We are told in Chapter 2 of Genesis that Eve was created full-grown out of Adam. Before she was known as Hera, the wife of Zeus had the name *Dione*. The name suggests the creation of Eve out of Adam, for Dione is the feminine form of *Dios* or Zeus. This suggests that the two were once, like Adam and Eve, a single bisexual entity.

Some mythologists say that Dios means light. Carl Kerényi says it means the actual "moment of lighting up." Thus the meaning of the names of the first couple, Dios and Dione, points to that time when they ate the fruit of the tree of the knowledge of good and evil and first em-braced the enlightenment of the serpent.

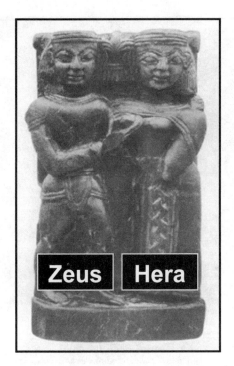

This wooden figurine of a couple is from the Greek island of Samos, ca. 620 BC. The eagle between their heads, a royal symbol of the king of the gods, suggests that this is Zeus and Hera—a picture of Adam and Eve, the first couple.

Pindar, in his *Sixth Nemean Ode* wrote this:

There is one
race of men, one race of gods; both have breath
of life from a single mother. But sundered power
holds us divided, so that one side is nothing, while on the
other the brazen sky is established
a sure citadel forever.

In his *Works and Days*, the poet Hesiod wrote of "how the gods and mortal men sprang from one source." The first couple, Zeus and Hera, were that source. Hera is the "single mother" of all humanity, and Zeus is, according to Homer, "the father of men and gods." The term "father Zeus" is a description of the king of the gods which appears over one

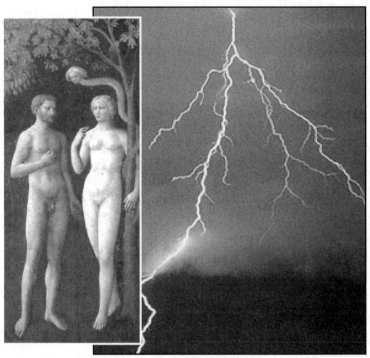

hundred times in the ancient poet's writings. As the source of their history, Zeus and Hera became the gods of their history.

Even Sokrates in Plato's *Euthydemus*, said that the gods were "his lords and ancestors." Those without a belief in the Creator have only nature, themselves, and their progenitors to exalt.

Adam's and Eve's moment of disobedience from the Judeo-Christian point of view, was to the Greeks the instant they welcomed enlightenment from the serpent—the moment of lighting up, the moment civilization and culture became possible. And with that possibility came the Greek expectation that the serpent's system would raise humanity higher in the scale of creation. In its myths and symbols, the Greek religious system pointed back to their beginning—that brilliant, lightning-flash of enlightenment that set human history on its course.

From the earliest times, the Greeks took a view of the serpent which contrasts sharply to the serpent's place in the Judeo-Christian tradition. To them, the serpent freed mankind from bondage to an oppressive God,

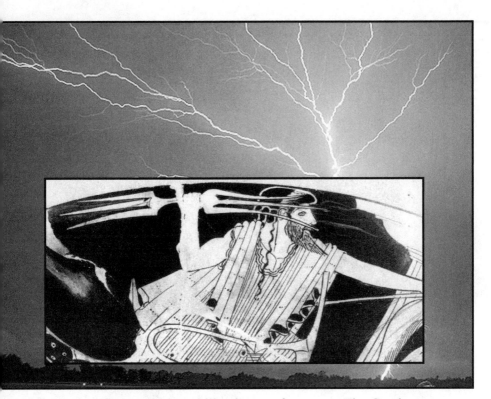

and was therefore a savior and illuminator of our race. The Greeks worshipped Zeus as both savior and illuminator; they called him Zeus *Phanaios* which means "one who appears as light and brings light." The light that he brought to the ancient Greeks was the serpent's light that he received when he ate the fruit from the serpent's tree.

In his *Zeus and Hera*, Carl Kerényi suggests that the name Zeus, at its deepest level, means "the actual decisive, dynamic moment of becoming light." The natural force, lightning, depicts who Zeus is and what he brings to mankind perfectly. It should not surprise us, then, that the attribute most closely associated with Zeus in ancient art was the lightning bolt. On the vase depiction from ca. 475, above, he holds the lightning bolt in his right hand. There is no more "actual decisive, dynamic moment of becoming light" than the time Adam and Eve received the serpent's enlightenment, and no more appropriate symbol for it than the lightning bolt of Zeus.

29

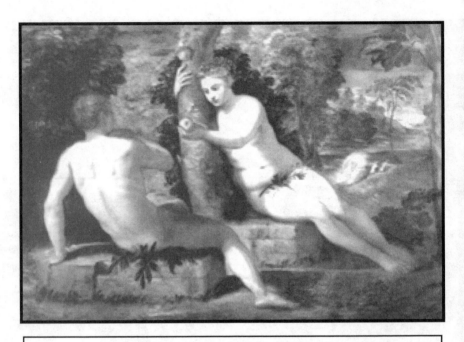

Eve shares her enlightenment with Adam in this oil-on-canvas by
Tintoretto from ca. 1550.

We read about the event pictured above, and the conversation leading
up to it in Genesis 3:1-6:

**And the serpent comes to be the craftiest of all field life which was made
by Yahweh Elohim. And saying is the serpent to the woman, "Indeed! Does
the Elohim say, 'Not eat shall you from any tree of the garden'?"**

**And saying is the woman to the serpent, "From the fruit of the trees of
the garden are we eating, yet from the fruit of the tree which is in the midst
of the garden, the Elohim says, 'Not eat of it shall you, and not touch it shall
you, lest you be dying.'"**

**And saying is the serpent to the woman, "Not to die shall you be dying,
for the Elohim knows that, in the day you eat of it, unclosed shall be your
eyes, and you become as the Elohim, knowing good and evil."**

**And seeing is the woman that the tree is good for food, and that it brings
a yearning to the eyes, and is to be coveted as the tree to make one intelli-
gent. And taking is she of its fruit and is eating, and she is giving, moreover,
to her husband with her, and they are eating.**

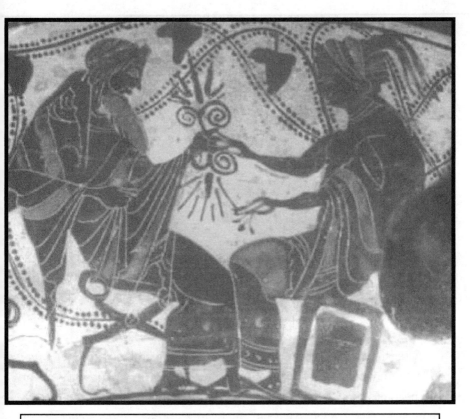

Hera shares her enlightenment with Zeus on this
vase depiction from ca. 475 BC.

Above, Hera passes the lightning bolt to her brother/husband, Zeus.
We've seen that the lightning bolt represents "the moment of lighting
up" in paradise; that is, the time of the taking of the fruit in accord with
the serpent's urging. This is the beginning of humanity's self-
consciousness, and Adam's and Eve's first knowledge of good and evil,
which changed everything for mankind. Hera's passing of the lightning
bolt, or the moment of enlightenment, to Zeus, matches the Genesis ac-
count: "And taking is [Eve] of [the tree's] fruit and is eating, and she is
giving, moreover, to her husband [Adam] with her, and they are eating."
Eve shared the enlightenment with Adam, as Hera is here pictured shar-
ing the enlightenment with Zeus.

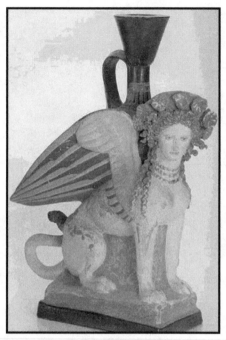

After they had both eaten the fruit, Adam named his wife Eve (*Chue* in Hebrew which means "Living") and Genesis 3:20 explains why: "For she becomes mother of all the living." In a hymn of invocation, the 6th century BC lyric poet, Alcaeus, refers to Hera as *panton genethla*, or "mother of all."

Above, a brilliant Greek artist from the late 5th century BC has exquisitely decorated a vase that relates to the first mother. The form of the neck, rim, and handle is that of a perfume receptacle, while the body is executed in the form of a sphinx. As we know from the story of *Oedipus Rex*, Hera originally controlled the sphinx, a riddle-uttering winged monster with the head of woman and the body of a lion. The wings of the sphinx symbolize power in the heavens; the body of the lion, power on earth, and the woman's head represents Hera, the mysterious Eve, the motherless mother of all living humans.

Imagine the time the artist took creating the curly hair and fine facial features. What female descendant of Eve today wouldn't treasure such a marvelous perfume container?

Above, *Adam and Eve*, oil-on-paper mounted on wood by Hans Holbein, 1517. Below, Zeus and his wife Hera, sculpted on the east frieze of the Parthenon, ca. 538 BC. Both traditions insist their pair was the first couple.

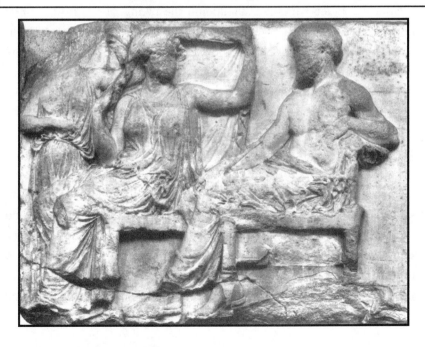

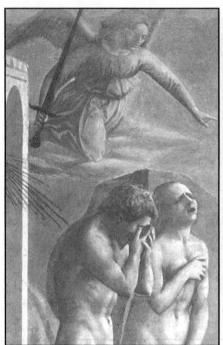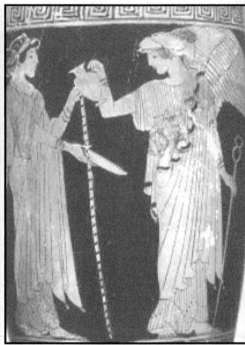

From the Judeo-Christian standpoint, the taking of the fruit by Eve
and Adam at the serpent's behest was shameful, a transgression of Yah-
weh's commandment. Michelangelo's painting, above left, depicts the
consequences of Adam's and Eve's act.

From the Greek standpoint, however, the taking of the fruit was a tri-
umphant and liberating act which brought to mankind the serpent's
enlightenment. Far from being considered the crafty seducer of the race,
the Greeks looked upon the serpent as their first schoolmaster and civi-
lizer who brought us the knowledge of good and evil. Adam's and Eve's
choice to believe the serpent in the garden was a positive transition from
the state of unconscious bondage to a state of conscious judgment and
freedom. Thus, on the vase painting, above right, from ca. 480 BC, Iris,
the messenger of Zeus, pays homage to Hera, the deified Eve and
"mother of all." In her extended right hand, Hera holds out a wide cup to
receive the drink offering from Iris. Hera's left hand holds her striped
scepter of authority, the top of which is obscured by the wine jug of Iris.

34

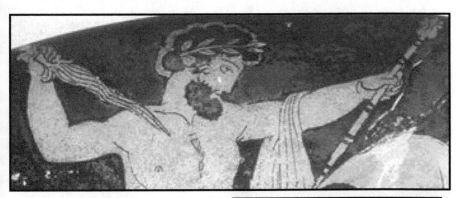

On a vase from ca. 410 BC, above, Zeus holds the scepter of rule and the lightning bolt. He is the naked and unashamed king of Olympus. The fruit of the tree has been passed to him. The serpent's enlightenment is the true source of his power. He carries the serpent's enlightenment in his right hand.

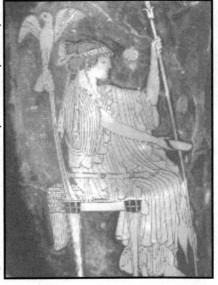

Hera's depiction, to the right, appears on a vase from ca. 490 BC. She sits enthroned with her scepter. She is, and always will be, the queen of Olympus. As the sister/ wife of Zeus and motherless mother of all humanity, Hera holds the scepter of rule by birth.

According to Genesis, Adam lived 930 years. The length of Eve's life is not mentioned but I think we can confidently state that it was about as long as Adam's. Adam and Eve lived nearly a thousand years each. That alone would confer a godlike status on them. And who came before them? No one. It is only natural that the Greeks worshipped Adam and Eve as Zeus and Hera. What the Greeks believed about the first couple is firmly anchored to early events described in Genesis. The great king and queen of the Greek pantheon are just Adam and Eve.

Chapter 3
Eden's Greek Counterpart

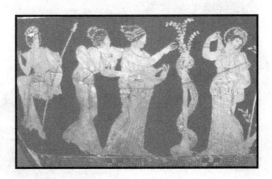

The Greeks remembered the original paradise. They called it the Garden of the Hesperides, and they connected Zeus and Hera with its enticing ease, and with the serpent-entwined apple tree.

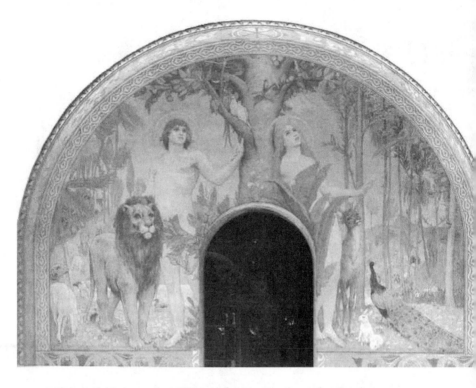

We read in Genesis 2:8-9:

And planting is Yahweh Elohim a garden in Eden, in the east, and He is placing there the human whom he forms.

And furthermore sprouting is Yahweh Elohim from the ground every tree coveted by the sight and good for food, and the tree of the living in the midst of the garden, and the tree of the knowledge of good and evil.

Above, we see how Victor Vatnetsov depicted Eden on a cathedral fresco in the Ukraine. The Hebrew word for Eden means "to be soft or pleasant," figuratively "to delight oneself."

In the Jewish tradition, we find a longing for a return to the paradise of God. In Ezekiel 36:35, the prophet envisions a day when the formerly desolate land of Israel, by the hand of Yahweh, will become "as the garden of Eden." Christians refer to this time as the millennial reign of Christ. After that age, according to the Book of Revelation, come a "new heaven and a new earth," wherein,

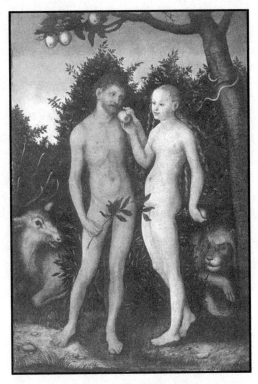

Adam and Eve
by Lucas Cranach
The Elder
1528.

"Lo! The tabernacle of God is with mankind, and He will be tabernacling with them, and they will be His peoples, and God Himself will be with them . . . And death will be no more, nor mourning, nor clamor, nor misery: they will be no more, for the former things passed away" (Revelation 21:3-4).

In the Judeo-Christian tradition, central to the longing for paradise are God's loving fulfillment of His divine operations and His very presence. In the Greek mythological tradition also, mankind longs for a return to the original paradise. The difference is that in the Greek tradition, the Creator is ignored, and the focus is the serpent's tree, and the goal is another big bite of the apple.

The Greeks referred to the original paradise as the Garden of the Hesperides. The Hesperides, the spirit-beings associated with this tree, its apples, and its serpent, get their name from *Hespere* in Greek which means evening, and that signifies the West where the sun sets. This

matches the Genesis account which describes civilization developing to the east of Eden. A return to Eden would mean traveling west. The Greeks put the Garden of the Hesperides, with its serpent-entwined apple tree, as seen above on a (sadly) damaged vase, in the Far West.

The Hesperides are always depicted in Greek art with a serpent entwined fruit tree. Some mythologists have mistaken them for guardians of the tree, but they certainly are not. Their body language, their easy actions, and their very names serve the purpose of establishing what kind of a garden this is: a wonderful, carefree place.

Opposite, we see the Garden of the Hesperides depicted on a water pot from ca. 410 BC. The serpent entwines the apple tree with its golden fruit. The names of the figures are written on the vase. Two Hesperides, Chrysothemis (Golden Order) and Asterope (Star Face) stand to our left

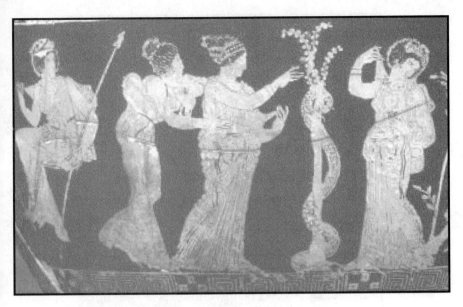

of the tree. Chrysothemis moves toward the tree to pluck an apple. Asterope leans pleasantly against her with both arms. To our left of them, Hygeia (Health) sits on a hillock and holds a long scepter, a symbol of rule, as she looks back towards the tree. To our right of the apple tree, Lipara (Shining Skin) holds apples in the fold of her garment, and raises her veil off her shoulder.

The names of the Hesperides describe what the garden is like. It's a land of soft starlight, gold for the taking, perfect health, and wondrous beauty. Apollodorus gives four different names for the Hesperides: Aegle (Dazzling Light), Erythia (Red Land), Hesperia (Evening Star), and Arethusa (Water Fountain). The sound of a water fountain is one of the most peaceful sounds. What an enchanting place!

If Adam and Eve, in the Greek religious system, have become Zeus and Hera, there should be some artistic or literary evidence for their presence in this garden. I haven't been able to find any sculptures or vases which put one or both of them next to the serpent-entwined tree, but the ancient travel writer, Pausanias, does tell us that the Hesperides scene was carved on a cedar chest in the temple of Hera at Olympia.

Greek literature is more helpful. Apollodorus wrote that the apples of

41

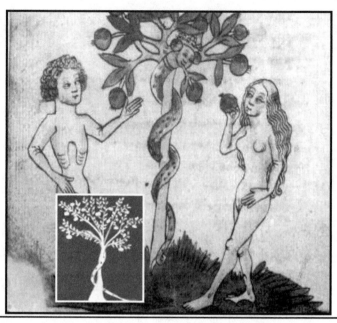

Above, Lutwin's *Temptation*, and inset, a Greek depiction of the serpent and the apple tree on a Greek cosmetics container from ca. 460 BC.

the Hesperides "had been given by Gaia (Earth) to Hera as a wedding present and Hera had asked the Nymphs to keep them for her. They were presented by Gaia to Zeus after his marriage with Hera." This matches the Genesis account: Eve became Adam's wife right after she was taken out of Adam (Genesis 2:21-25), and the next recorded event is the taking of the fruit. The important point is that this passage from Apollodorus connects Hera and Zeus with the serpent and the tree.

The chorus in Euripides' play *Hippolytus* speaks of "the apple-bearing shore of the Hesperides" where immortal fountains flow "by the place where Zeus lay, and holy Earth with her gifts of blessedness makes the gods' prosperity wax great." Thus Euripides put Zeus in the garden, and his language affirms that this is where Zeus came from.

You have probably heard one time or another about Eve eating the apple. The Hebrew word for fruit in Chapter 3 of Genesis is a general term. The idea that Adam and Eve took a bite of an apple comes to us as part of the Greek tradition.

And Atlas through hard constraint upholds the wide heaven with unwearying head and arms, standing at the borders of the earth before the clear-voiced Hesperides; for this lot wise Zeus assigned him.

Hesiod, *Theogony*

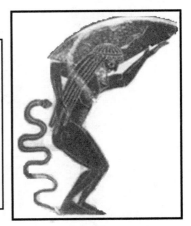

The Greek poets placed a figure named Atlas in the ancient Garden of the Hesperides. His presence there clarified their religious viewpoint, for it was his job to put the authority of heaven at a distance from them.

Above, we see two depictions of Atlas from ca. 550 BC: the one to the left from a shield band panel, and the other from a plate scene. On both depictions, he is pushing away the heavens. On the one to the right we can see where the artist has drawn stars. As Atlas pushes away the heavens, he also pushes away the God of the heavens—which is the very object of his efforts. Victory for the Greek system means that the Creator is kept at bay, pushed out of the picture, and His influence nullified, so that men become free to believe what they will (See *Athena and Eden*, Chapter 9). The way of Greek religion, the way of Kain, is a life lived without God's "interference" with mankind's desires. The Creator must be pushed away and ignored if Zeus-religion is to succeed.

Yahweh cursed and condemned the serpent in Genesis 3:14: "On your torso shall you go, and soil shall you eat all the days of your lives." As God is pushed out of humanity's realm, the curse on the serpent becomes void. He rises up, as on the plate depiction above, to take his place as the illuminator and enlightener of the race.

Chapter 4
The Way of Kain

The case of Kain, the first man born of a woman, and the first murderer, should be of tremendous interest to the rest of the human race. The Greek religious system would be impossible without him, for it is based on him and his proverbial way, a way which exalts mankind and ignores the Creator. The Greeks deified Kain whose family became forgers "of every tool of copper and iron" (Genesis 4:22) as Hephaistos, god of the forge and armorer of the gods.

The first family depicted in marble by Quercia Grossa, ca. 1428.

According to Genesis 4:1-2, after the transgression in the garden, Eve bore two children to Adam:

And the human knows Eve, his wife, and pregnant is she and is bearing Kain. And saying is she, "I acquire a man, Yahweh!" And proceeding is she to bear his brother Abel. And coming is Abel to be the grazier of a flock, yet Kain becomes a server of the ground.

Then in Genesis 4:3-5, the way of Kain begins to be defined:

And coming is it, at the end of days, that bringing is Kain, from the fruit of the ground, a present offering to Yahweh. Abel also is bringing, he, moreover, from the firstlings of his flock, and from their fat. And heed is Yahweh giving to Abel and his present offering, yet to Kain and to his present offering He does not give heed. And hot is Kain's anger exceedingly, and falling is his face.

God Prefers Abel's Sacrifice, from the Genesis Art Gallery.

The story presupposes the institution of sacrifice. Adam and Eve most likely taught their children this by example.

Kain had not been given faith, and consequently he had sinned by rejecting God's way of approach to Him, preferring instead his own way of approach. According to the scriptural viewpoint, Kain did not do well because he had brought a present that did not speak of Christ, but spoke only of Kain's works. It was Kain's own gift that he had labored for (though actually it also was from God) and now gave to Yahweh. God persists with words that point to Christ, saying to Kain in Genesis 4:6-7:

"Why is your anger hot? And why does your face fall? Would you not, should you be doing well, lift it up? And should you not be doing well, there is a sin offering reclining at the portal, and for you is its restoration. And you are ruler over it."

These words spoken by Yahweh are words of evangel, a well-message, directing Kain in a way that will be well, or good, for him. God

knows that Kain's "fruit of the ground" offering will not do, so He provides for Kain a "sin offering," most likely a sheep such as Abel sacrificed. Kain, however, is not interested in the sacrifice God has provided.

For the human to approach God in the way which is good, there must be a witness to the Savior Who would shed His blood for sinners. This could only be done at that time by a picture, a type of the real Approach Present and Sin Offering, Who, according to Scripture, is Jesus Christ.

Continually throughout these verses, God points ahead to Christ and His death for sinners. He heeds Abel's approach present because it reflects the death of God's Son for the conciliation of His enemies, and He does not heed Kain's present because it fails to speak of Christ. By His words of evangel (well-message, good news) to Kain, God directs attention to an animal that could serve as a type of the Lamb of God who takes away the sin of the world.

God is not in need of either flesh or fruit, so it has no value for Him as far as nourishment is concerned. The issue is subjection. This takes us to the meaning of the Hebrew word for God, *El*. Its literal meaning is Subjector. It is often attached to words such as Israel (*Yisra-El*, he will rule as Subjector) and Ezekiel (*Ychezqe-El*, Subjector will strengthen). Abel, in his sacrifice, is subject to God. Kain's original self-serving sacrifice, and his rejection of the sacrifice God provides for him, demonstrates his insubjection to the Supreme Subjector.

Abel looks to God, the Subjector. This is the basis of Judaism and Christianity. Kain rejects the Subjector and his means of salvation, and looks instead to himself and to the serpent to see what it has to offer. This is the basis of the ancient Greek religious system. The Creator is left out: mankind will determine its own destiny.

What the Supreme Subjector tells believers through His prophets and apostles in the Scriptures contrasts sharply with the Greek worship of graven images of the serpent and long-dead humans.

God was pleased with Abel's present because it not only set forth the way of salvation by suffering and reconciliation by death, but also gave Him His place supreme. Abel did not insult Him by giving the last and

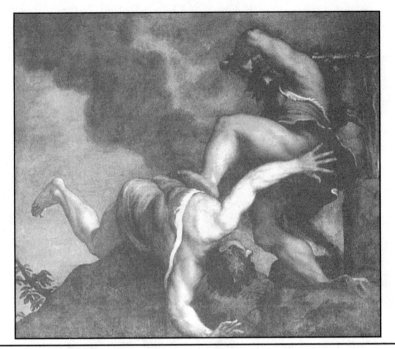

Kain kills Abel.

worst, but the first and best.

Abel's present offering, besides being firstlings, included the fat which was on their viscera. This speaks to us of the deep, inner richness of God's compassions. Abel gave Yahweh, not only the first, but also the most *feelingful*. Greek religion developed a system of animal sacrifice and, true to the way of Kain, the worshipper gave the inferior part of the animal to Zeus and the other gods.

Kain remained locked up in stubbornness and insubjection. He added evil to evil by murdering his brother Abel:

And saying is Kain to Abel, his brother, "Go will we to the field." And coming is it, at their coming to be in the field, rising is Kain against Abel, his brother, and killing him (Genesis 4:8).

From the scriptural viewpoint, Kain was "of the wicked one." From the Greek viewpoint, the killing of Abel was part of the process of breaking free from the dictates of an oppressive god.

Genesis 4:22 tells us that the members of Kain's family were the first to become forgers "of every tool of copper and iron." The Greeks worshipped Kain as Hephaistos, the forger of weapons for gods and heroes in the Greek religious system (See Chapter 6 of *Athena and Eden*).

Hephaistos was the eldest son of Zeus and Hera, just as Kain was the eldest son of Adam and Eve. Above, on the drawing of a vase from ca. 480 BC, Thetis, the mother of Achilles, comes for the armor Hephaistos has made for her famous warrior son. Below, on a vase from ca. 550 BC, Hephaistos carries his double-headed axe as he rides his winged chariot.

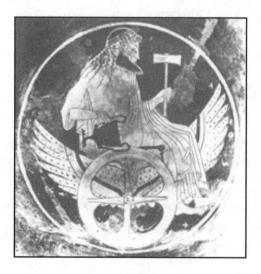

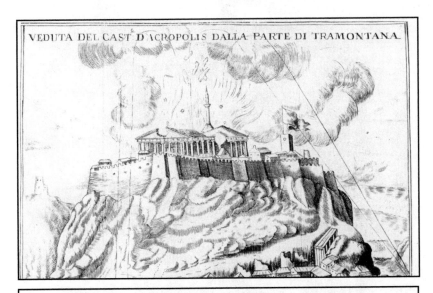

F. Fanelli's 1707 Drawing of the Parthenon Explosion of 1687.

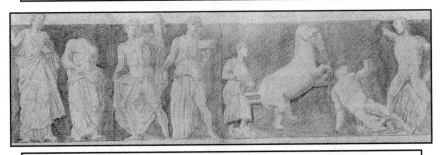

Jacques Carrey's Drawing of Four of the South Central Metopes, 1674.

The Greeks portrayed Kain's killing of Abel on the south side of the Parthenon in a series of four metopes. The originals were blown to bits in the explosion of 1687 when the Turks, besieged by the Venetians, used the Parthenon as a gunpowder magazine. On September 26th, the Parthenon took a direct hit from a Venetian shell and the powder stored there exploded. Fortunately, Jacques Carrey, a French artist, had drawn all the metopes on the south side in 1674, including these four. According to scholars these are four of the nine "mysterious south-central metopes." But look at the metopes individually on the next two pages and see how they match the story of Kain and Abel in Genesis.

51

First metope: two men talk. One is taller and presumably older than the other. Kain and Abel.

Second metope: Kain becomes upset over a sacrifice his wife is planning to offer. The dispute with Abel had affected Kain's domestic life.

Third metope: Genesis: "And saying is Kain to Abel, his brother, 'Go will we to the field.'" Kain's intentions startle Abel and his horses in the field.

Fourth metope: Genesis again: "And coming is it, at their coming to be in field, rising is Kain against Abel, his brother, and killing him."

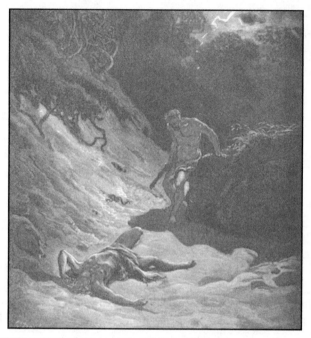

After Kain killed Abel, Yahweh spoke to him saying,

"What have you done? The voice of your brother's blood is crying to Me from the ground. And now, cursed are you by the ground, which opens its mouth wide to take your brother's blood from your hand. As you are serving the ground, it will not continue to give its vigor to you. A rover and a wanderer shall you become in the earth" (Genesis 4: 10-12).

Kain didn't wander very long. He soon settled down and built the first-ever city. Kain's defiance of Yahweh and his return from wandering became known in Greek myth as "the return of Hephaistos."

Genesis 4:17 tells us that Kain built this city in opposition to Yahweh's command. Adam and Noah built none. As we shall see, Cush and Nimrod built the first city in this age at Babel—the very spot where Yahweh had dispersed mankind. As A. E. Knock has written, "Cities display the highest achievements of mortals and glorify mankind. The word city (naked in Hebrew) indicates that the ground has been denuded of vegetation. But living, growing plant life is God's achievement, and reminds us of his vital power, wisdom, and glory."

Above, Dionysos beckons Hephaistos to return with him to Olympus. Below, the same theme by a different vase artist, who puts tongs in the hands of Hephaistos to be sure we can identify him.

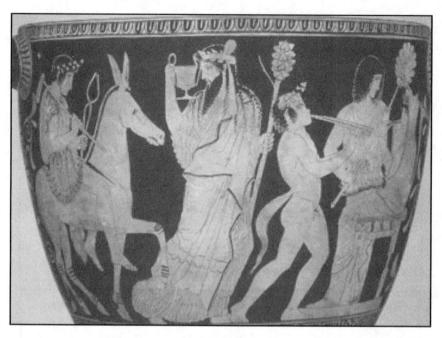

The return of Hephaistos to Olympus is a "myth" which appeared painted, sculpted, and bronzed throughout the Archaic and Classical periods. This tells us that his return to Olympus constituted an essential element of Greek religion. Hephaistos returned to Olympus after being banished by either Hera or Zeus or both. The banishment of Hephaistos from Olympus in Greek religion corresponds to Kain's being commanded to wander the earth by Yahweh in Genesis: "A rover and a wanderer shall you become in the earth" (Genesis 4:12).

Kain wandered for a time but then defied Yahweh again and ceased his wandering:

And knowing is Kain his wife and she is pregnant and bearing Enoch. And coming is it that he is building a city, and calling is he the name of the city as the name of his son, Enoch (Genesis 4: 17).

The return of Hephaistos to Olympus corresponds to Kain's defying Yahweh's command to wander, and his building a city instead. Out of that city, the line of Kain prospered as he and his offspring embraced the wisdom of the serpent.

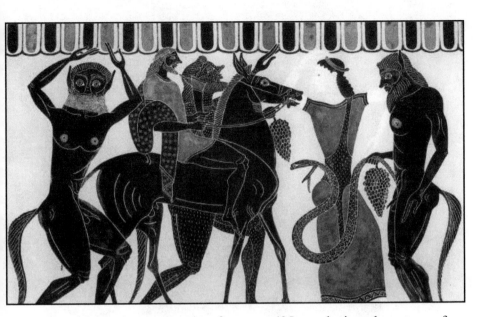

The drinking cup, opposite, from ca. 425 BC depicts the return of Hephaistos, the deified Kain, to Olympus. Dionysos, in the center, looks back over his shoulder and beckons Hephaistos to follow him to the abode of the gods. They approach Hera who is seated on a golden throne from which she cannot rise to rule until Hephaistos has returned. This is a picture of the moment the Greek religious viewpoint originated. When Kain defied Yahweh's command to become a rover and a wanderer in the earth, and established instead a city and a culture opposed to Him, he figuratively returned to Olympus—to the realm of Zeus and the serpent's enlightenment.

Dionysos, a god of soulish and sensuous pleasures, holds up a *kantharos* or wine-drinking cup. Kantharos in Greek means dung-beetle, or scarab, an ancient symbol of transformation. This is the time Kain went from being an outcast to becoming immortalized as Hephaistos, the armorer of Zeus-religion—a grand transformation, indeed.

Above, we see another painting from the Archaic period depicting the return of Hephaistos. Dionysos walks on the other side of Hephaistos' mule, while a member of his bestial entourage (a satyr) carries a serpent, signifying that it is the serpent's realm to which Hephaistos returns.

57

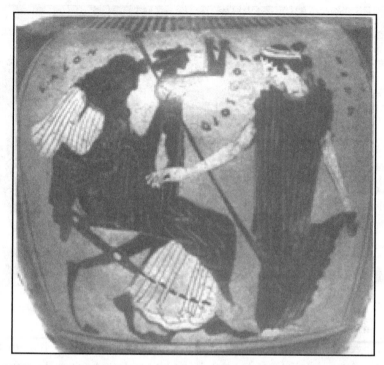

In these return scenes, Hephaistos is almost always depicted as riding a mule, a symbol of stubbornness now as well as then. Are the vase artists saying that the realm of the ancient serpent is where Kain's stubbornness has taken him?

As a reward for his return, Hephaistos received the beautiful Aphrodite as his wife. Just as Kain's wife had to have been his sister, so Aphrodite is the sister of Hephaistos. Zeus is the father of both, and Aphrodite's mother, Dione, is the same woman/goddess as Hera, but from a different oral tradition.

In Plato's dialogue, *Cratylus*, Sokrates says that Hephaistos means "Princely Lord of Light." According to Robert Graves, his name is a contraction of *hemeraphaestos* which means "he who shines by day." On the vase above, we see the young Hephaistos standing on his father's lap in the presence of his mother, Hera. He holds two torches and is hailed as "light of Zeus." Hephaistos shines because he is Eve's eldest son, Kain, who embraces Zeus-religion and the serpent's enlightenment.

Chapter 5
Ares—The Hated Son of Zeus and Hera

Abel died at the hands of Kain without offspring. Eve gave birth to Seth who then became Adam's and Eve's youngest son. The Greeks deified Kain as Hephaistos, god of the forge. They deified his younger brother as Ares, god of conflict and war. In the Judeo-Christian tradition, Kain is the evil one whose way is to be shunned. In the Greek religious system, Ares, the Seth of Genesis, is the traitor and "bane of mortals."

After Kain murdered Abel, we read in Genesis 4:25:

And knowing is Adam Eve, his wife, again. And pregnant is she and bearing a son. And calling is she his name Seth, saying, "For set for me has the Elohim [God] another seed instead of Abel, for Kain kills him."

Technically, Adam and Eve had three children: Kain, Abel, and Seth. But Kain killed Abel before he had offspring. Since Seth replaced Abel, we look at Adam and Eve as having two children, each of whom, in turn, had offspring. In the Scriptures, the line of Seth is the line of Christ. The Book of Matthew traces the lineage of Christ through David to Abraham; and the Book of Luke further traces the lineage of Abraham to Adam through his son Seth. This is often referred to as the line of belief in the Creator-God or the line of faith in Him. On the other hand, the Scriptures define the line of Kain as one of unbelief in the Creator-God. According to I John 3:12, "Kain was of the wicked one," a straightforward reference to "the ancient serpent called Adversary and Satan, who is deceiving the whole inhabited earth" (Revelation 12:9).

Now if Zeus and Hera are pictures of Adam and Eve, we would expect them to have two antagonistic male children just as the first man and woman did. Zeus and Hera had two male children: Hephaistos, the elder, and Ares; and they were as averse to each other as Kain and Seth.

Look up Ares in almost any mythology book, and you will likely read something similar to this: "Ares, son of Hera and Zeus, was the Greek god of war. A lover of Aphrodite, the Romans identified him with Mars." Unless you dig a little deeper, you miss the fact that Athena and Ares were enemies, and that his own father, Zeus, despised him.

Zeus referred to Ares as a renegade. That means "an apostate from one's faith or party, especially one who deserts to a hostile faith or party; a traitor, a turncoat." Since the Greek system was simultaneously history and religion, there was a legitimate basis for the hostility. Kain killed one brother and lived in perpetual enmity with his replacement, Seth.

Homer refers to the youngest son of Zeus and Hera as "Ares, the bane of mortals." A bane causes ruin and woe, and is the source of irreparable harm. That's how the other Greek gods looked on Ares.

Ares pictured on an Attic black figure vase from ca. 550 BC.

As we shall see in Chapter 11, and as those who have read *Athena and Eden* already know, Athena represents the rebirth of the serpent's Eve after the Flood. As such a key goddess in the serpent's system, she ought to hate Ares, and she does. In the Trojan War she helped the mortal Greek warrior, Diomedes, wound Ares. Ares went to Olympus for healing and approached his father, Zeus, who, in Homer's *Iliad*, railed at him thus:

"Sit thou not in any wise by me and whine, thou renegade. Most hateful to me art thou of all gods that hold Olympus, for ever is strife dear to thee and wars and fightings. Thou hast the unbearable, unyielding spirit of thy mother, even of Hera; her can I scarce control by my words. Wherefore it is by her promptings, meseems, that thou sufferest thus. Howbeit I will no longer endure that thou shouldest be in pain, for thou art mine offspring,

Ares pictured on an Attic red figure vase from ca. 520 BC.

and it was to me that thy mother bare thee; but wert thou born of any other god, thus pestilent as thou art, then long ere this hadst thou been lower than the sons of heaven."

Zeus has called his son "hateful" and "pestilent." Think of it this way: this is Zeus, the serpent's Adam, railing at Yahweh's Seth. From the Judeo-Christian standpoint, this is the way Yahweh's Adam would disparage the serpent's Kain.

The only reason Ares has a place in the Greek pantheon is that he is the son of Zeus; that is, he is one of the two actual sons of the first couple, Adam and Eve, of whom Zeus and Hera are deifications. Zeus hates this son, but accepts responsibility for siring him: "for thou art mine offspring, and it was to me that thy mother bare thee."

Many people say Greek religion is anthropomorphic; that is, gods take human form. That's not exactly right. What happens is that real human ancestors retain their original identities and take on godlike qualities. Ares, as a deification of Seth, is trapped, in a sense, by the historical framework. As we shall see in coming chapters, the Greek gods will continue to hate him, and Greek heroes will even kill his children.

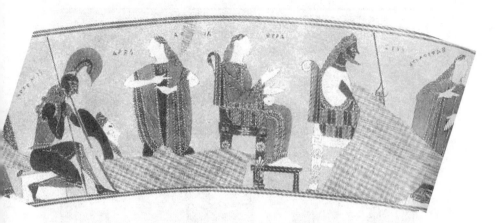

Above, we see a very revealing scene from the famous François vase. Hera and Zeus sit enthroned. Out of our view to the right, Hephaistos, led by Dionysos, approaches his mother and father. Hephaistos, the deified Kain, is returning from exile to promote Zeus-religion. This is cause for great celebration in the Greek system. From the Judeo-Christian point of view, this represents Kain's decision to defy Yahweh's command to wander, and instead build a city in which the way of Kain will prosper.

Another important part of the story—the fact that Ares wanted to bring Hephaistos back but was blocked by Athena—is hardly preserved in ancient sources, but has been reconstructed from allusions and from representations, such as the above.

At the far left, Ares kneels behind Athena on a low block, crestfallen at his failure to bring back Hephaistos. Athena, looks back towards Ares, mocking him. Ares may be an Olympian god, but he must submit to his subordinate place in the serpent's system.

From the standpoint of Zeus-religion, Ares/Seth must be stopped from bringing back his brother Hephaistos/Kain. If Ares/Seth were to bring back his brother, Hephaistos/Kain, out of exile, that would be untrue to the historical reality, and the whole Greek religious standpoint would fall apart.

While the scriptural viewpoint defines Seth/Ares as the Yahweh-believing, or spiritual son, Greek religion defines him as hated by, and antagonistic to, the ruling gods who are part of the serpent's system.

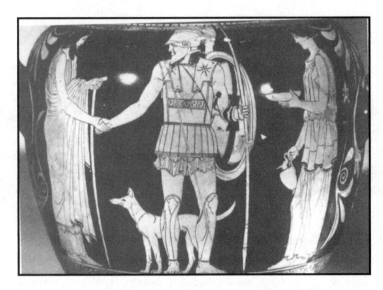

Likewise, while Zeus-religion looks on Hephaistos/Kain as the true and devoted son, the scriptural viewpoint defines him as "of the wicked one." This is human history. Ares *could not* bring back Hephaistos because Seth *did not* bring back Kain.

Jews and Christians dislike and shun the line of Kain, but they can't get rid of him or his line without altering their spiritual standpoint and history itself. Kain is part of the Hebrew Scriptures (Genesis to Malachi) and the Greek Scriptures (Matthew to Revelation), and he is there to stay. Zeus-religion has the same kind of situation. It hates the line of Ares, but it cannot eliminate the line from its history, for the basic achievement of Zeus-religion is the triumph of the way of Kain over the way of Seth. Ares is part of Greek sacred literature and art, and he is there to stay.

The above vase-painting from the Classical period with Hephaistos to the left shaking hands with Ares appears to me to be an artistic expression of that realization. Hephaistos and Ares are reconciled, but only in a certain sense. The line of Kain has triumphed, Zeus-religion rules the Greek world, and Ares acknowledges that he has been integrated into the Greek religious system, and he accepts his place in it.

Let's move on and examine the interaction of the line of Seth with the line of Kain that led up to the Flood.

Chapter 6
The Line of Seth Takes Kain's Women

Before the Flood, the line of Seth intermarried with the line of Kain, and over time merged into it, leaving Noah's family as the only one with an untainted connection to Seth. Those events are related in Chapter 6 of the Book of Genesis.

The Greeks remembered these same events as the stealing of the line of Kain's women by the Kentaurs.

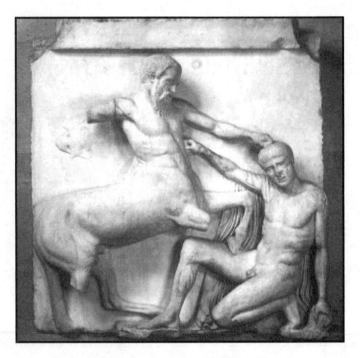

The theme of the thirty-two south metopes on Athena's temple, the Parthenon, is the Lapiths fighting the Kentaurs. In most of the scenes that depict one-on-one fighting, the Kentaurs, as above, are getting the best of the Lapiths. Not only that, the Kentaurs are carrying off the Lapith women as in the metope, opposite. What is going on here?

First, these are not Greeks but Lapiths, a word that, according to Robert Graves, means "Flint-chippers." This suggests great antiquity. Some ancients write that the Lapiths were from Northern Greece, but there is no record of any Lapith settlements. The Lapiths existed before the Flood, and Greek myth bears this out.

This taking of the Lapith women occurred at the wedding of a man named Perithous. The Kentaurs showed up and supposedly got drunk (they don't look drunk in any of the sculptures), and carried off Perithous' wife, Hippodameia, and other women. Some chroniclers get mixed up as to when this happened. We know it happened before the Flood because the Greek hero, Herakles, went to Hades to retrieve

Perithous and the hero Theseus. Herakles was able to bring Theseus out of Hades because that Greek hero lived in Herakles' own era. He could not bring back Perithous, because he had lived before the Flood.

The Kentaurs represent the line of Seth; the Lapiths, the line of Kain. I can't say for sure where the name Kentaur comes from but I suggest two possibilities, both of which may be true. The root meaning of the Greek word *Kentauros* is hundred. The Romans took it over as *kenturion* (centurion), the leader of a hundred soldiers, and it comes down to us as a cent, and a century. Not only did Noah build an ark, he heralded for a hundred years that the Flood was coming: "[For God] spares not the ancient world, but guards Noah, an eighth, a herald of righteousness, bringing a deluge on the world of the irreverent" (II Peter 2:5).

Noah was 500-years-old when he learned of the coming Flood and 600-years-old when it happened (Genesis 5:32, 9:28-29). As a herald or proclaimer of righteousness (belief in Yahweh), Noah warned for a cen-

tury that the world would be inundated. The unbelievers derided him, and most likely said words to this effect: "That moron has been proclaiming that for a hundred years." As Noah was part of the line of Seth, it is natural that the Greeks would associate his relatives with this hundred-year-long proclamation.

Then, in the Chaldean language from Babylon where the image of the Kentaur originated, the word *çûwç* means horse, and the Kentaurs were depicted as half-men/half-horses. A word that is pronounced almost identically in Chaldean, *çûwph*, means "terminate, or have an end, perish." The horse-part of the Kentaur may have been a homophonic word-picture which connected to the reason that the line of Kain perished during the Flood. As we shall see later in this chapter, Genesis suggests very strongly that it was this taking of the women that led to the Flood; and as we shall see in the next chapter, the Greeks specifically blamed the Kentaurs for bringing an end to the line of Kain during the Flood.

On the storage jar above from ca. 530 BC, three Kentaurs walk to our left, each carrying a symmetrical branch over their left shoulders. From

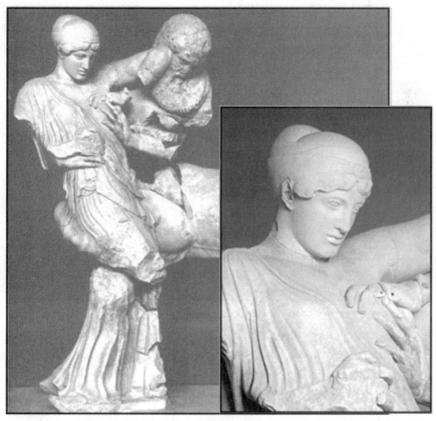

the perspective of the line of Kain, this branch identifies them as part of that "strange branch" of humanity, the line of Seth.

Kentaurs dominated 5th-century BC Greek public sculpture. The west pediment of the temple of Zeus at Olympia featured the Kentaurs seizing the Lapith women at the wedding of Perithous, the king of the Lapiths. The Greek myth that Ares/Seth had an affair with Aphrodite, wife of Hephaistos/Kain, expresses the depth of the desire of the Seth-men for the beautiful Kain-women.

Above, from that pediment, a Kentaur grasps Hippodameia, the wife of Perithous, to carry her off. Hippodameia does not fight him. Her impassiveness indicates that she is going to be carried off no matter what she does. What happened can't be changed, but as we shall see in Chapter 17, after the Flood, the taking of the Kain-women will be avenged.

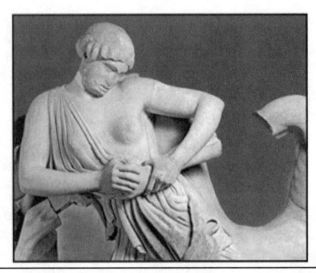

From the west pediment of the temple of Zeus at Olympia, a Lapith woman (the line of Kain) puts up a futile struggle against a Kentaur (the line of Seth).

The difference between the line of Kain and the line of Seth concerns the question of subjection. Kain and his line reveled in their insubjection to the Supreme Subjector, Yahweh. The name of Kain's great-grandson, Mehujael (*Mchui-El*), expresses his line's great antipathy to the Supreme: it means "Wipe-out Subjector."

Seth was subject to God, and he was expected to subject the rest of humanity in his domain, especially his direct offspring, to God. The subject of Chapter 5 of Genesis is the annals of Adam—the record of the whole line of first-borns through Seth down to Noah. Each of these men, when his father died, was to function as the subjector of humanity while he lived, and then at death pass the rule on to his son. But something happened to the line of Seth before the Flood. Only Noah's family escaped the Deluge. Why? Wasn't the line of Seth in subjection to the Subjector? Genesis 6:9 reads:

These are the genealogical annals of Noah: Noah is a just man. Flawless became he in his generations. With the Elohim walks Noah.

Noah was flawless in his generations, but the rest of the line of Seth, by taking women from the line of Kain, had become flawed in their gen-

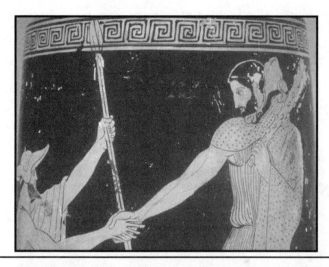

On this oil jar from ca. 465 BC, Herakles grasps the hand of Perithous in Hades. He can't bring him back because he is from the pre-Flood age. Their eye contact and hand grip show agreement. Herakles vows to avenge the taking of the Lapith women by the Kentaurs.

erations. While the line of Kain refused to be subject to God, the line of Seth failed in not subjecting *others*.

Seth, and after him, each successive first-born son lived about two hundred years after the death of his predecessor, when he took over the place of Adam as the head of humanity. Yet, at the end of the line, only Noah, with his family, was free from the prevailing insubjection. If the reason for the prevailing insubjection to God was that the men in the line of Seth had taken women from the line of Kain for their wives, where does it say so in Genesis? It says so in Genesis 6:1-8, but before I cite that, we need to look at the meaning of the words Elohim (capitalized) and elohim (not capitalized), which appear in that passage.

We already know that the term El for God in Hebrew means Subjector and refers to the Supreme Subjector Who is Yahweh, or God the Father, the omnipresent Spirit. Elohim (capitalized) refers to God as He is working through others, especially Christ. When in the Hebrew texts, Elohim, a plural word, is used to refer to the Supreme Spirit, it always takes a singular verb. That is because, according to Scripture, God al-

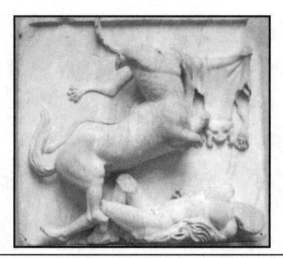

On this metope from the south side of the Parthenon, a Kentaur crushes a Lapith.

ways operates through Christ and sometimes in turn through lesser beings, as One Spirit. The word **Elohim** refers to the One True God, **El**, as He is subjecting His creation through other beings.

The word elohim (not capitalized) refers to human subjectors, or ruling magistrates. For example, the words of Moses brought many into subjection to the God of Israel, and in that sense he is one of the elohim, one of those who played a part in subjecting others to God.

Before the Flood, God established Adam and his first-born successors through Seth as elohim, or subjectors. Genesis 5:1 states that the Supreme Subjector created Adam in His likeness; that is, as a subjector. Genesis 5:3 states that Adam, in turn, begot Seth "in his likeness, according to his image." This shows that Adam was the subjector, or ruling magistrate, of humanity while he lived, and that he passed this on to Seth. Seth inherited Adam's authority because Abel had no offspring before he was murdered by Kain, and Kain did not honor God or wish to bring any into subjection to Him. Thus Seth inherited the rights as Adam's first-born elohim, or subjector, by double default.

Now we are in a position to understand Genesis 6:1-8:

And coming is it that humanity starts to be multitudinous on the surface of the ground, and daughters are born to them. And seeing are sons of the

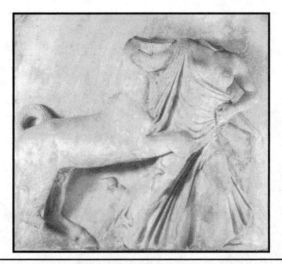

On this south metope from the Parthenon, a Kentaur, using his
arms and forelegs, seizes a Lapith woman.

elohim [human subjectors in the line of Seth] the daughters of the human,
that they are good, and taking are they for themselves wives of all whom
they choose.

And saying is Yahweh Elohim "Not abide shall My spirit in the human
for the eon, in that moreover, he is flesh. And come shall his days to be a
hundred and twenty years."

Now the distinguished come to be in the earth in those days, and, more-
over, afterward, coming are those who are sons of the elohim [human sub-
jectors in the line of Seth] to the daughters of the human, and they bear for
them. They are masters, who are from the eon, mortals with the name.

And seeing is Yahweh Elohim that much is the evil of humanity in the
earth, and every form of the devices of its heart is but evil all its days.

. . . Yet Noah finds grace in the eyes of Yahweh Elohim.

Men in the line of Seth took "for themselves wives of all whom they
choose" (Genesis 6:2). Subsequent verses in the above passage reiterate
this intermarriage of the lines, saying it happened after the days in which
the distinguished came to be in the earth. It seems evident that the
"distinguished" were Lamech's father, Methuselah, and Lamech's grand-
father, Enoch. Why were they distinguished? Genesis 5:22 says "And
walking is Enoch with the Elohim, after his begetting Methuselah, two

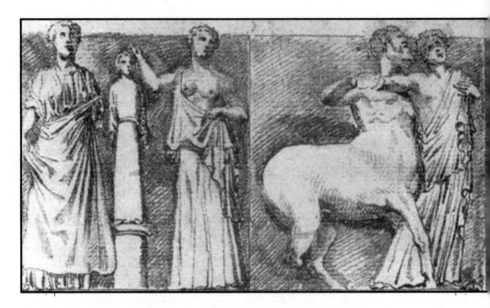

hundred years." Walking with the Supreme is something that would set any man apart from his associates. Methuselah is distinguished because he was alive during the time his father walked with the Elohim and because he lived for nine hundred and sixty-nine years, the longest of any human in Scripture.

The final breakdown of the ruling order of subjectors in the line of Seth occurred sometime during the lifetime of Noah's father, Lamech. Of the eight generations from Seth to himself, Lamech is the only one whose words are recorded in Scripture, so we know that they are very significant. He says of his son, Noah, "This one will console us because of our doings, and because of the grief of our hands, because of the ground Yahweh Elohim makes a curse" (Genesis 5:29). It remains for Genesis 6:1-4 to explain what "our doings" refer to. What went wrong in Lamech's time was this: Lamech's brothers and sons (other than Noah), and his uncles, took their wives from the line of Kain.

The taking of the Lapith women is the way the Greeks remembered this traumatic reality from before the Flood. Greek sculptors took great pains to associate the Lapith women with their goddess, undoubtedly an Eve/Hera figure. As we look at the Parthenon's south metopes numbers

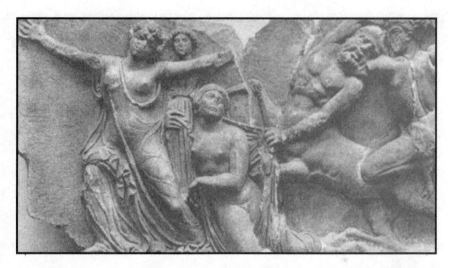

21 and 22, opposite, as drawn by Jacques Carrey in 1674, we see a Kentaur carrying off a woman from the line of Kain, as other women in the line of Kain cling to their goddess. Above, from the temple of Apollo at Bassae, we see the same theme depicted with more intensity. In the face of the onslaught of the Kentaurs, the women in the line of Kain exhibit fierce determination to keep their religion intact.

The Kentaurs (Seth-men) overpowered, abused, and carried off the Kain-women, yet these women refused to change their beliefs! That is what the clinging women represent, and that is how the line of Seth became corrupted. We've seen that the key Kain-woman taken by the Seth-men was Hippodameia, the wife of Perithous, king of the Lapiths. Hippodameia means "Horse-tamer." The half-men/half-horses may have taken the women of the line of Kain by force, but those same devoted Kain-women eventually tamed their captors from the line of Seth!

In a nutshell, to use Paul's words in II Corinthians 6:14, the line of Seth became "diversely yoked with unbelievers." And according to the apostle, that is the same as trying to establish a partnership between "righteousness and lawlessness," and the same as trying to create a communion between "light and darkness." "Or what part [has] a believer with an unbeliever?" According to the scriptural viewpoint, God's judgment on the ancient world is inevitable.

Herakles is pictured in Greek vase art on page 71 as vowing to Perithous, husband of Hippodameia, to avenge what the Kentaurs (Seth-men) had done to the Kain-women before the Flood. We'll see in Chapter 14 that conquering the line of Seth after the Flood on behalf of the line of Kain was the essence of Herakles' mission in life.

Above, on a wine-drinking cup from ca. 550 BC, Herakles is pictured in the process of killing three Kentaurs. Below, on a storage jar from the same period, Herakles kills the Kentaur Nessos who is thus unsuccessful in his effort to carry off the hero's wife, Deïaneira.

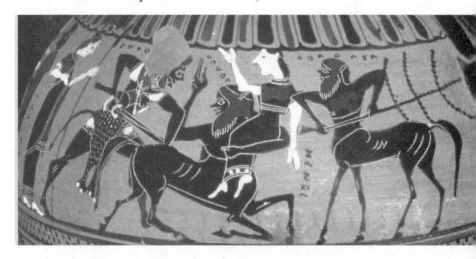

Chapter 7
The Flood Wipes Out the Line of Kain

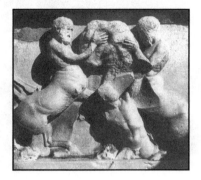

The Flood temporarily wiped out the line of Kain. The Greeks pictured this cataclysmic event as Kentaurs pounding a man named Kaineus into the ground with a rock. Kaineus means "pertaining to Kain," or more directly, "the line of Kain."

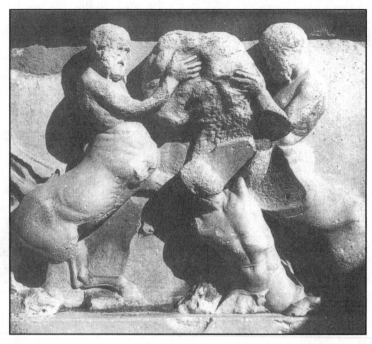

If you have not yet read *Athena and Eden: The Hidden Meaning of the Parthenon's East Façade*, I recommend that you do. It will convince you that the Scriptures in general and the Book of Genesis in particular hold the key to understanding the "myths" the Greeks recorded in their art and literature. Now let's take a look at a very important sculpture not discussed in *Athena and Eden*, and see how what is written in the Book of Genesis gives us the essential knowledge we need to understand it.

This above sculpture is part of the west frieze on the temple of Hephaistos in Athens. Built from 460 to 450 BC, the temple of Hephaistos stood on a little hill across from the agora, the hub of ancient Athens. It was the Athenians' most easily accessible major temple.

What's happening in the above scene? Two Kentaurs grasp a large rock. Working in concert, they pound a man into the ground. The oft-regurgitated view is that the Kentaurs represent barbarianism, and that somehow the artist is warning his fellow Greeks to beware of the uncivilized way of life and those who embrace it. But that interpretation is much too simplistic and way off the mark.

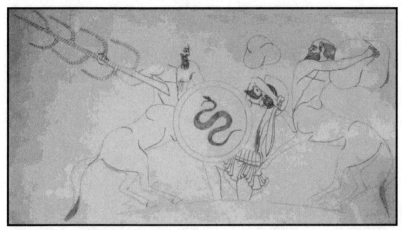

We don't know how many artists worked on this sculpture, but we can estimate that it would have taken one sculptor between a year-and-a-half to three years to complete it. That was a very serious undertaking; the figures are quite plain to us even after about 2,440 years. That is because they were meant to last and mean something to us. If I could conjure up the ghost of the sculptor, or one of the sculptors, who chiseled these two Kentaurs hammering a man into the ground, I believe he'd say something like this:

This sculpture means a great deal to us.
We Greeks created the living basis of your culture.
Therefore, this sculpture should mean a great deal to you.

This sculpture was part of a public building in ancient Athens. As the heirs of ancient Greek culture, it belongs to us now. In order to understand it, we need to establish some missing connections.

The theme of a man, whose name we will find to be *Kaineus*, being beaten into the ground is not original with this sculpture. Above, a drawing by Sir John Beazley of a vase from about a hundred years earlier depicts two Kentaurs beating Kaineus into the ground. The shield of Kaineus features the ancient serpent, to whose religious system Kain is devoted. One Kentaur holds a branch which represented, to the Greeks, that other "strange branch" of humanity—the line of Seth. In the above scene, the artist has drawn the branch as a weapon as well as a symbol.

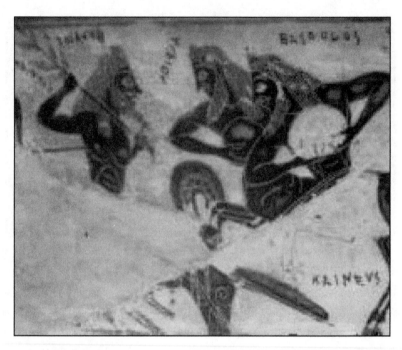

We know from ancient literature and from a scene on the neck of the famous François vase from the 6th century BC, above, that the name of the man being beaten into the ground was Kaineus. Three named Kentaurs pound him into the ground, and to our right of him, the vase painter has written his name—KAINEUS. The word for the eldest son of Adam and Eve as it appears in the Greek Scriptures is KAIN.

Kaineus does not represent just one man. In Greek, *eus* at the end of a noun very often means "stemming from or pertaining to" that particular noun. For example in Greek, *Hippo* is a horse; *Hippeus* means pertaining to a horse, or horse-like. So with Kain-eus, we have pertaining to Kain, stemming from Kain, or the offspring of Kain. Kaineus is the human representation of the entire line of Kain. The sculpture and the many vase paintings tell us that which pertains to Kain; that is, the line of Kain, gets pounded into the earth by a strange branch of humanity. Note that the Kentaur to our left, above, carries a branch which in no way can be mistaken for a weapon. We have already seen that this "strange branch" of humanity is the line of Seth.

80

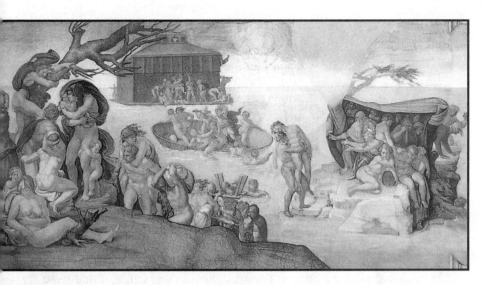

"And I, behold Me bringing a deluge of water over the earth to wreck all flesh, which has in it the spirit of the living, from under the heavens. All that is in the earth shall expire" (Genesis 6:17).

[For God] spares not the ancient world, but guards Noah, an eighth, a herald of righteousness, bringing a deluge on the world of the irreverent (II Peter 2:5).

Above, we see Michelangelo's painting of the destruction of all humanity save Noah and his family. Below, we see the ancient Greek interpretation of that same horrifying, traumatic event depicted on a vase from ca. 550 BC.

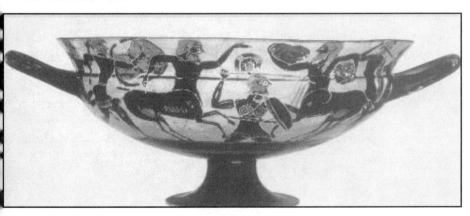

If you are using your skeptiosity, you'll wonder why Kain must be pounded in the head, as opposed to being stabbed in the heart or neck, for instance. That's a very good question with a very revealing answer. In Genesis, the line of Kain is considered to be the serpent's seed. They were the humans who embraced the way of Kain, welcomed the serpent's enlightenment, and rejected the rule and worship of Yahweh. All of Adam's and Eve's offspring before the Flood knew of Yahweh's curse on the line of Kain. It appears in Genesis 3:15:

"And enmity am I setting between you and the woman and between your seed and her seed. He shall hurt your head and you shall hurt his heel."

The Greeks looked back at the pounding of Kaineus into the ground by rock-blows to the head as the fulfillment of this curse. If that were the end of the story, there wouldn't be any Greek religion embracing the way of Kain. But that wasn't the end of the story. The line of Kain came back into being after the Flood. Thus, the hurting of Kain's head put an end to the curse without putting an end to the line of Kain.

The Greeks referred to Kaineus, the line of Kain, as invulnerable, but how, specifically, did Kain's line come back into being after the Flood? The way the Athenians told the story, Athena took the sperm, or seed, of Hephaistos, put it on a piece of wool and placed it into the ground. And out of that same ground into which Kaineus had been pounded, the line of Hephaistos, or Kain, reemerged in the form of a very special child, Erichthonios, "the Earth-born One." And the curse was finally overcome, as was Noah's patriarchal rule.

We'll go into more detail on this in Chapter 16, but now let's examine how the Greeks remembered Noah and the Flood.

Chapter 8
Nereus—the Greek Noah

The Greeks remembered Noah as Nereus, the "Wet One." Nereus appears on a surprising number of vases where his identity as the Noah of Genesis is impossible to resist acknowledging.

Noah and Nereus

To the right, we see a depiction of Nereus from an Attic black figure water pot, ca. 515 BC. In *The Meridian Handbook of Classical Mythology*, here is how Edward Tripp describes Nereus:

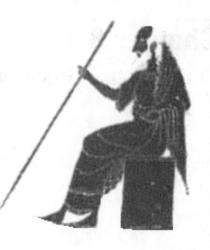

An ancient sea-god. Nereus, a son of Pontus (Sea) and Ge (Earth), may have had considerable importance before Poseidon became the ruling sea god. He is referred to by both Homer and Hesiod as the Old Man. Hesiod explains that this is because he is kind and just. He was the father, by the Oceanid Doris, of the fifty sea-nymphs—the Nereïds. Like other sea-deities, he had prophetic powers. Herakles, led to his home by the Nymphs, captured him sleeping. Herakles bound him and refused to release him until he revealed the location of the Garden of the Hesperides.

According to Robert Graves, Nereus means "Wet One." He is Noah, the one who came through the Flood; that's why the Greeks associated him with Sea and Earth. The ancient poets called Nereus the "Old Man of the Sea." According to Genesis, Noah lived 600 years before the Flood, and 350 years after it. Some ancient writings referred to Nereus as the "Salt Sea Old Man." Nereus (Noah) lived long enough to sire fifty daughters whom the Greeks called Nereïds.

The Book of Genesis does not name Noah's wife, but the Greeks said that the wife of Nereus was the Oceanid (Okeanid) Doris. What made her an Oceanid was the fact that she rode the ocean in the ark with Nereus/Noah and their family for a year.

And of course Nereus/Noah had prophetic powers—for a hundred years he had predicted the Flood that eventually wiped out the line of Kain. As he was the living link to the days before the Flood, Herakles had to go to him to find out the location of the serpent's ancient garden— the Garden of the Hesperides.

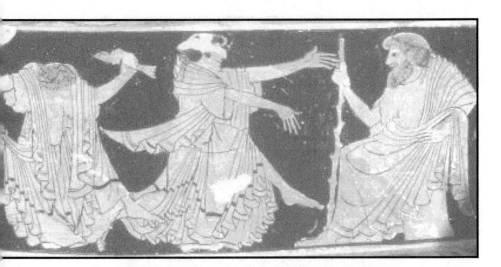

Hesiod wrote in his *Theogony*, "And Sea begat Nereus, the eldest of his children, who is true and lies not: and men call him the Old Man because he is trusty and gentle and does not forget the laws of righteousness, but thinks just and kindly thoughts." In Genesis 6:9 we read: "Noah is a just man."

The memory of Nereus, to the Greeks, was of more than "considerable importance," for Hesiod took the time to name all fifty of his daughters whom, he wrote, "sprang from blameless Nereus, skilled in excellent crafts." Greek artists and poets treated the Old Man of the Sea as a personage of permanent significance, giving him the respect his patriarchal standing was due.

On the vase depiction above from ca. 490 BC, he appears as a seated spiritual figure enjoying the devotion and affection of his daughters, the

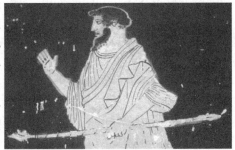

Nereïds. On other vases as well, he appears as a man of paternal tenderness whom his daughters seek to embrace. On the depiction of him to our right from ca. 450 BC, the artist has given Nereus a scepter, suggesting regal authority without a throne.

We have to jump ahead to a time after the Flood to explain what happened to Nereus. Nereus could be remembered and honored in the Greek religious system, but as part of the line of Seth, he could not be worshipped. That's where Triton, pictured above on a vase from ca. 490 BC comes in. He is a benign sea god with a fish-tailed lower body. The scepter and the dolphin that he holds let us know that he rules the sea, or once ruled it.

Pausanias makes the mistake of calling him a monster, but as we can see from the depiction of him at the top of the opposite page from ca. 510 BC, this is clearly not the case. There, with full human torso, arms, and facial features, he holds a dolphin in his left hand and a fish in his right. He was often helpful, as when he appeared to the Argonauts stranded in Libya, and directed them to the sea. Over time, he came to signify Noah's legacy and the power of the sea. Triton became a symbol with which the hero Herakles was able to grapple.

The vase depiction of Herakles and Triton, opposite, tells the whole story. Herakles harms or kills many of his opponents, but not Triton. Here, he wrestles with him, grabbing him from behind. Notice the interlocking hands of Herakles. He is coming to grips with Noah's legacy. On the vase, he is wrestling it away from the Old Man of the Sea who stands

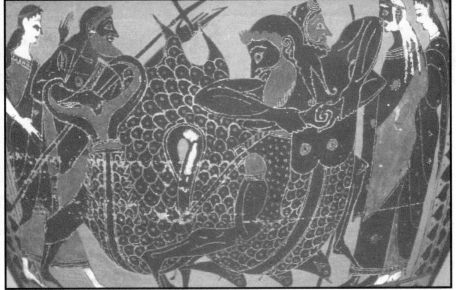

to the right leaning on his staff with a daughter, disconsolate at the turn of events he can do nothing to prevent. On the left, behind Triton's tail, stand Poseidon (with trident) and his wife, the Nereïd Amphitrite, who bend toward the action with their arms upraised, in gestures that indicate their involvement with its outcome.

What a magnificent painting! Herakles is wrestling away Nereus' association with the power of the sea and giving it to Poseidon, a brother of Zeus. Poseidon becomes god of the sea and its power. Nereus has a place in Greek history, but no place on Olympus.

Above, we see two other depictions from ca. 520 BC of Herakles com-
ing to grips with Triton—Noah's legacy. If the artists had wanted to
show Herakles killing a monster, they would have made it very obvious
as they did on many other vases where killing was part of the action. But
on these vases and many others, the artists make Herakles' grip on Triton
the focal point of the encounter. He is wrestling away Noah's authority
and power, seizing it for the developing Greek religious system. Human-
ity ceased fearing the God of Nereus, and instead began to fear Herakles,
and worship the gods of Zeus-religion.

There is another way this power-exchange is related in Greek myth.
Poseidon was said to have married Amphitrite, one of the daughters of
Nereus and Doris (Noah and his wife). In this way, the offspring, or seed,
of Nereus became his. Then it was said that Triton was the child of Po-
seidon and Amphitrite, meaning, of course, that Triton—the power of the
sea—belonged to these Greek deities. The vase context on the previous
page suggests that Herakles adopted Triton into the Greek religious sys-
tem, or more accurately, kidnapped him on Poseidon's behalf.

The memory of Noah's Flood, deeply rooted in the minds of the an-
cient Greek artists, inspired thousands of vase paintings related to it. As
we shall see in the next chapter, the sculptors in Athens even went so far
as to depict the Flood and its aftermath on the west pediment of their
most treasured temple, the Parthenon.

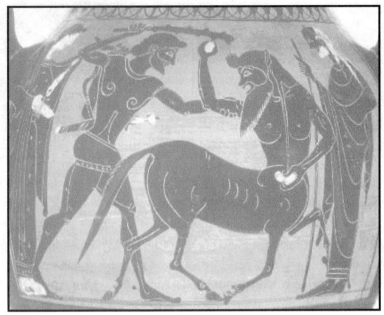

Greek vase paintings are a constant source of surprise and delight. The depiction above from ca. 525 BC is pregnant with truth of the deepest import. Herakles wields a club against a rock-throwing Kentaur. Athena stands behind Herakles, and Nereus, the Greek Noah, stands to our right, stoically observing the action.

It reminds me of Charlemagne's premonition. His reign was secure, but he wept as he looked out over the sea saying, "I feel great violent sorrow when I foresee what evils the sea pirates [Vikings] will heap upon my descendants and their people."

We could title our vase, "The Premonition of Nereus." The Kentaur that Herakles is subduing represents the line of Seth. During the Flood, the line of Kain had been pounded into the earth by a huge boulder in the hands of the Kentaurs. Now, several hundred years after the Flood, the Kentaur's rocks are small, and the club of Herakles is big.

The power behind Herakles is Athena, the reborn serpent's Eve. The seeds of Nimrod's rebellion were sown during the latter part of the lifetime of Nereus/Noah, and according to this vase artist, he stood as a mute and powerless witness to the great spiritual change to come.

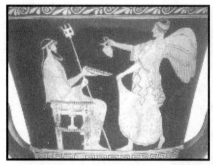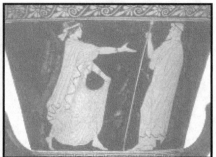

Above, we see scenes from opposite sides of a vase from ca. 470 BC. The scenes relate to each other, presenting a sequel to Herakles' coming to grips with Triton, the legacy of Nereus, the Greek Noah. On one side, Poseidon holds a one-man victory celebration. Nike, the winged goddess of victory, walks left and pours an offering of wine to the sea god who now sits enthroned, trident in hand. But over whom has Poseidon achieved his victory? We go to the other side of the vase to find out. There, a Nereïd rushes to the right, an arm outstretched toward her father, Nereus, here depicted as a bearded man holding a scepter. She presents him with the bad news: Poseidon has taken over. Poseidon's victory comes at the expense of Noah and the line of Seth.

Greek "mythology" chronicles the reestablishment of the way of Kain after the Flood. We've seen that Greek myth reaches back and tells the story of what happened before the Flood. As we shall see in the next chapter, Greek myth tells what happened during the Flood. Greek myth is a history of humanity, and great historical figures are included in that history, including Nereus, the Greek Noah. But Greek myth is colored by the fact that its focus is the history of the development of a very specific religious standpoint and system. Thus, pushing Noah into the background, and replacing him with Zeus' brother, Poseidon, is an essential part of that history.

On the vase depiction on the opposite page from ca. 480 BC, Nike stands in the center between two folding stools, where Amphitrite and Poseidon sit facing each other. Nike, with her wings spread, turns her head toward Amphitrite. She holds a wine jug in her right hand and a

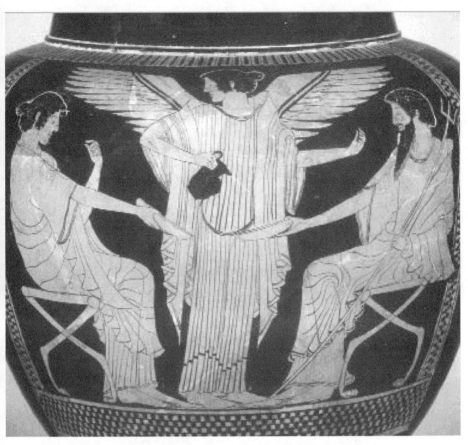

small red flower in her left hand which blends into the black in the illustration. Amphitrite also holds such a flower in her left hand; and in her right hand, she holds a drinking bowl out of which she is pouring into the ground the wine Nike has given her. Poseidon also pours out the wine from the bowl in his right hand. His left hand holds his trident.

The flowers in the hands of Amphitrite and Nike represent the beginning of the flowering of the Greek religious system. As a daughter of Nereus, Amphitrite used to belong to him. As the wife of Poseidon, she now belongs to the new god of the sea, and has become part of the Greek religious system. This is the victory they are celebrating. By pouring out wine into the earth, they are ritually sealing their victory over Nereus, and affirming their place in the Greek pantheon.

Chapter 9
The Flood Depicted on the Parthenon

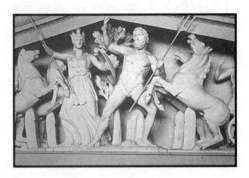

The west pediment of the Parthenon depicted the Flood and its aftermath. Poseidon left behind a pool of saltwater as the ocean receded from the Akropolis. Then Athena presented the people of Athens with an olive tree, the symbol of the new age after the Flood.

Poseidon usurped the power of Nereus, the Greek Noah, by taking his daughter Amphitrite. The pediment does not feature Noah, but alludes to him through the presence of his daughter and son-in-law.

Reconstruction of the west pediment of the Parthenon.

According to the conventional view, the center of the west pediment of the Parthenon depicts the so-called contest between Athena and Poseidon for control of the Akropolis, the city itself, and all of Attika, the surrounding region. In some versions of the myth, the contest was held to determine whose name the city would bear. Athena and Poseidon each were to give a gift, and the greater gift would win the city. The exact identity of the judges of this "contest" is muddled. They are variously said to have been the other Olympian gods, Zeus alone, one of many kings of Attika, or the populace as a whole.

Poseidon went first. He raised his trident and struck the earth atop the Akropolis. It trembled and split apart in that place. Then, right there—four miles inland—a salt spring miraculously appeared where no water had been before. This demonstration of Poseidon's great power impressed the judges, whoever they were.

Now it was Athena's turn. She caused an olive tree to sprout up nearby. Without hesitation, the judges favored Athena's gift and named the city after her.

Athena's gift makes sense if we relate it to the Book of Genesis. There, the dove returns to Noah with a torn-off olive leaf in its beak, and the olive tree becomes a sign of the new age after the Flood. Athena takes the olive tree as her own symbol, establishing herself as humanity's source of direction and enlightenment. Poseidon's side of the story, however, is unconvincing. His gift of a salt spring on the Akropolis is a worthless offering to the people of Athens. It must mean something else.

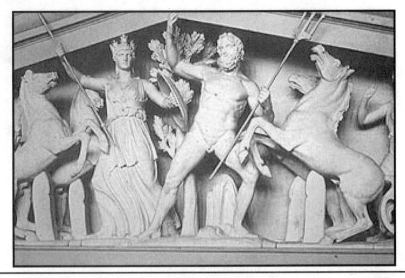

Athena and Poseidon in the center of the west pediment of the Parthenon.

In the book, *Worshipping Athena: Panathenaia and Parthenon*, edited by Jenifer Neils, contributor Noel Robertson relates that no well of any kind exists on the top of the Akropolis, and concludes that "this strange well with sea-water did not go down very far; perhaps it was more of a basin." This crucial bit of research helps substantiate the idea that, rather than depicting a preposterous contest between deities, the west pediment of the Parthenon portrayed part of humanity's history—the Flood and its aftermath. Poseidon is the god of the power of the sea. During the Flood, he covered the Akropolis. What Poseidon left behind as his waters receded was a basin, or pool, of salt water—not a spring. Thank you, Professor Robertson.

What is framed in myth as a contest between Athena and Poseidon is in reality a straightforward depiction of a familiar, earth-shaking historical event. Poseidon is the god of the sea, or more accurately, the god of the *power* of the sea. During the great Flood, Poseidon's salt water covered the Akropolis. As the waters subsided, he left a salt water pool as a reminder of his power. Upon the sea god Poseidon's departure, the goddess Athena usurped the symbol of the olive tree and began her rule of the new Greek age. It's as simple as that.

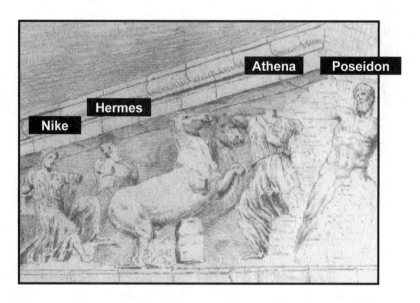

Let's look at the central figures in more detail. Fortunately, we have the drawings of Jacques Carrey from 1674 to help us. I'd like to have Poseidon where he belongs, on the same page with Iris and Amphitrite, but that's not the way Mr. Carrey drew the scenes.

We'll examine those three figures first. In the reconstructed model of the west pediment on the previous page, Poseidon holds his trident in his left hand. But both extant vase depictions of the central scene show Poseidon holding his trident in his right hand, apparently pulling it up and away (see pages 100 and 101). I appreciate the work of those who put the west pediment model together, but in this case, I'm going to trust the ancient vase painters. Poseidon, the power of the sea, is depicted as having struck the ground with his trident, causing the earth to quake and split. When he did that, water gushed forth. This matches the account of the Deluge in Genesis. Water came first from below, then from above:

On this day rent are all the springs of the vast submerged chaos, and the crevices of the heavens are opened, and coming is the downpour on the earth forty days and forty nights (Genesis 7: 11-12).

Poseidon has rent "all the springs of the vast submerged chaos" releasing the great Flood upon the earth. The poets Pindar and Homer both

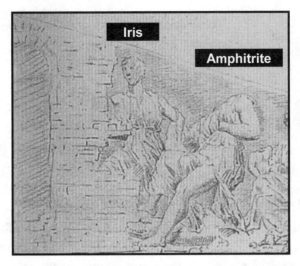

call him "the Earthshaker." But he is stepping back from his action of striking the earth with his trident, indicating that the Flood is over. Amphitrite, Poseidon's chariot-driver and wife, tells us what happened next. In Greek myth, Amphitrite, a daughter of Nereus, is associated with dolphins because she was reluctant to marry Poseidon until a messenger named Delphin persuaded her to do so. Delphin is a word related in meaning to Delphi, the site of Apollo's oracle, thus suggesting their marriage was ordained by the gods. Dolphins appear as the sea grows calm. Amphitrite here represents the calm sea, the non-threatening sea. This also agrees with the Genesis account:

And the Elohim [God] is causing a wind to pass over the earth, and subsiding are the waters. And being held in check are the springs of the submerged chaos and the crevices of the heavens, and being shut up is the downpour from the heavens, and returning are the waters off the earth, going and returning.

Note that the wind caused the waters to subside. The same thing happens today, at least where I live. After it rains, the wind comes and takes the dampness away with it. Amphitrite's garb depicts the wind. This is the observation of B. F. Cook, the former Keeper of Greek and Roman Antiquities in the British Museum. He bases it on Amphitrite in the above drawing. Mr. Cook writes:

Amphitrite from Carrey's 1674 drawing.

The goddess [Amphitrite] wears a peplos girt with a belt high below the breasts and open at the side so that, as the drawing shows, the lower part was swept back by the wind, leaving the left leg bare.

Thus it is very possible that her figure represents not only the calming sea, but the wind which dried it up as well. The ripples in the dress of Iris, whose figure survives as a headless, armless torso with legs to the knees (pictured on the opposite page) also depict the action of the wind.

As we have seen, Amphitrite is one of the Nereïds, the fifty daughters of Nereus, the Greek Noah. This is a direct connection to the Flood-events described in Genesis. Nereus can't be depicted here because he is part of the line of Seth, and what the Greeks are affirming on the west pediment is that the serpent's system, the way of Kain, has taken over after the Flood. Undue attention to Nereus distracts from that. That's why Poseidon, the brother of Zeus, has become the god who represents the power of the sea.

Behind Amphitrite and the chariot stands Iris. Iris means "Rainbow" in Greek. According to Olga Palagia, two large symmetrical cuttings at her back, made with large diameter drills, indicate the attachment of marble wings, suggesting that she is delivering a message to earth from the celestial realms. The rainbow's message is that the seas will remain calm. This also accords with the Genesis account. The rainbow's association with the Deluge is widely known. In Chapter 9 of Genesis, Yahweh explains that he will not inundate the world again, and as a sign of this covenant with humanity, he leaves the rainbow:

"My [rain]bow I bestow in a cloud, and it comes to be for a sign of the covenant between Me and the earth. And it comes, when I cloud over the earth with a cloud, then appears My [rain]bow in the cloud, and I am reminded of My covenant, which is between Me and you and every living soul in all flesh, and there is not to come a future deluge of water to wreck all flesh."

While Amphitrite portrays the calming sea and the wind which causes it to recede and make the land reappear, Iris brings the rainbow's message that such a Flood will not occur again. These depictions of Poseidon, Amphitrite, and Iris on the right of the pediment express the essential elements of the Genesis account of the Flood. The difference is that Yahweh is behind the Genesis event and Zeus is behind the rendition of it on Athena's temple, the Parthenon.

With the depictions of Athena, Nike, and Hermes to our left of the center of the pediment, the Greeks give us a concise overview of what happened after the waters of the Deluge receded. Athena, a

Iris, or "Rainbow," from the west pediment of the Parthenon, now in the British Museum, London.

chosen instrument of the serpent's system, takes over. Her birth after the Flood (the rebirth of the serpent's Eve) is the theme of the east pediment. Back on the west pediment, Nike guides her chariot establishing the goddess' victorious preeminence in this age. If this great Greek goddess is to rule the minds and hearts of humanity, she needs the help of a believer and a prophet. She needs Hermes. Hermes assisted the Three Fates in the cultivation of the olive tree. That means Hermes was the first, after the Flood, to receive the serpent's enlightenment from her, nurture it, and develop it into a religious system. Nike's presence speaks of Athena's and Hermes' joint victory.

Chapter 12 is about Hermes, so I'll just relate here that he is a deification of Cush, who founded Babylon and led the effort to unite humanity—without Yahweh—in the building of the infamous tower there.

To my knowledge, there are only two extant vase depictions of the center of the west pediment of the Parthenon: the one above, and the partially damaged one, opposite, both from the Late Classical period. Each artist has put what appears to be an olive tree in the center. On one, a serpent coils upward on the tree. On the other, the lightning bolt of Zeus comes down on the top of the tree.

On the vase above, Hermes appears to our left of Athena, just as on the Parthenon; and Iris appears flying in the sky next to Poseidon. A fish swims between Poseidon's legs indicating the receding flood waters. On the depiction opposite, the woman next to Poseidon looks to be Amphitrite. A sea creature swims at their feet, probably Triton, the symbol of the sea's power that Herakles has wrestled away from Nereus, or Noah.

The lightning bolt of Zeus and the serpent, as symbols, relate to the same event. The lightning bolt signifies the enlightenment of the serpent from Eden. Now that the Flood is over, the serpent returns to enlighten humanity and to rule the Greek age, symbolized by the olive tree, through Athena. The lightning bolt has the advantage of representing the serpent's enlightenment *and* calling attention to a sudden, significant change on earth directed by Zeus.

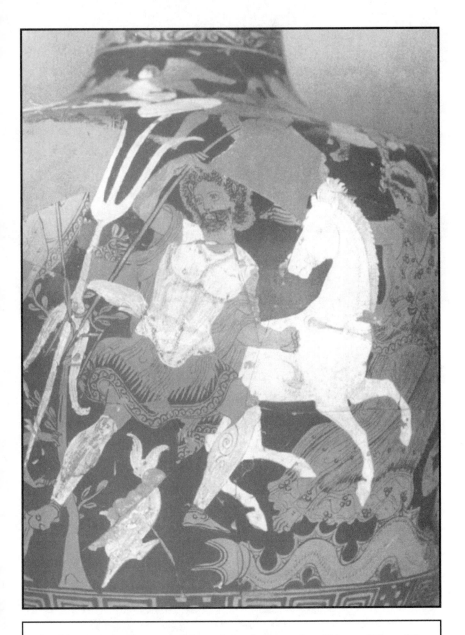

On this water pot from ca. 400 BC, the artist has painted his rendition of the center of the west pediment of the Parthenon. Poseidon's body language matches Carrey's drawing and the surviving sculpture.

Chapter 10
The Transfigured Serpent

Chapter 4 of *Athena and Eden* goes into detail about the relationship between the ancient serpent and Zeus. For those who have not read it, this chapter is a convenient summary.

John C. Wilson wrote that anthropologist Jane Ellen Harrison "understood, as no one did before her, that in spite of their great intellectual achievements the Greeks belonged in the main to the world of primitive religion." The superstitious Greek, she thought, entered the presence of his gods as though he were approaching the hole of a snake, for the snake had been to his ancestors, and was still to him and many of his contemporaries, literally and actually a god. A lifetime of study led her to believe that Greek religion, for all its superficial serenity, had within it and beneath it elements of a deeper and darker significance. She concluded that Zeus, the Olympian father god, had tended to erase from men's minds the worship of himself when he bore the title Zeus *Meilichios*, or Zeus the "Easily-entreated One," and took the form of a serpent who demanded from his devotees the sacrifice of a pig.

The relief on this page, dating from the 4th century BC, was uncovered at the harbor of Athens. Inscribed above the coiled beast is the phrase "To Zeus Meilichios." Ms. Harrison wrote of this figure: "We are brought face to face with the astounding fact that Zeus, father of gods and men, is figured by his worshippers as a snake." The serpent's beard on the relief above signifies that it is the "ancient serpent."

As we see from the reliefs on the page opposite, some Greeks engaged in outright serpent worship. In both reliefs, the serpent does not crawl on its torso and eat soil as it was condemned to do in Genesis 3:14, but rises up to receive the adoration of humans. The Greeks called this serpent by the same name—Zeus Meilichios—that they called the king of the gods who took the form of the first human, Adam. What has happened? The serpent blended with, and transfigured into, the image of "the father of gods and men"—Zeus. Jane Ellen Harrison wrote of this

104

Above, a man and his child approach the serpent in worship.

On the relief to the right, a woman and two men approach Zeus as the serpent with gestures of adoration. Both are from the 4th century BC.

On the relief below, worshippers approach an enthroned man identified with the same words as the serpent on the opposite page—Zeus Meilichios.

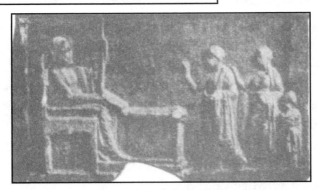

strange transfiguration of the ancient serpent into human form: "And the truth is nothing more or less than this, the human-shaped Zeus has slipped himself quietly into the place of the old snake-god."

The Scriptures express the same idea as Greek religion, albeit from a different perspective. Revelation 12:9 identifies the "ancient serpent" by the titles Adversary and Satan, and the apostle Paul in II Corinthians 11:14 asserts that "Satan himself (the ancient serpent) is being transfigured into a messenger of light." The name Zeus means light, and at its deepest level, it means the actual "moment of lighting up" in Eden.

Revelation 12:9
II Corinthians 11:14

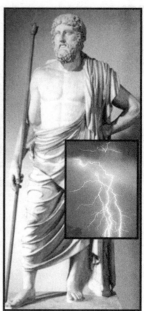

The serpent himself is being transfigured into a messenger of light

The half-man/half-serpent, Kekrops, above, appears in sculpture and on a great many vases in the Classical period. In part, he symbolizes the transfiguration of serpent-worship into the more sophisticated Greek religious system with Zeus at its head.

Zeus embodies serpent-worship, and yet conceals it. The idol-images of Athena, Apollo, Hermes, Hephaistos, Hera, Artemis, and other Greek gods often appeared attended by serpents, but Zeus never. Why? The presence of snakes around the other gods indicated that they were part of the serpent's system of enlightenment and sacrifice. But Zeus is not a subordinate part of the serpent's system—he is the transfigured serpent.

Chapter 11
The Rebirth of the Serpent's Eve

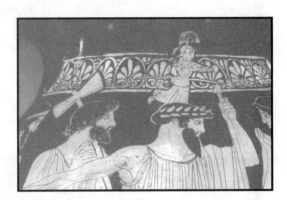

One of Athena's nicknames was *Tritogenia* or "Thrice-born." As the serpent's Eve, she was born for the first time full-grown out of Adam. Then at the apple tree, she was born a second time when the serpent birthed her into his system of enlightenment. The Flood wiped out the line of Kain and the serpent's system to which it was dedicated. And so Athena's third birth came after the Flood, as the rebirth of the serpent's Eve.

In their depictions of her, vase artists and sculptors almost always identified Athena with the ancient serpent, sometimes in more ways than one.

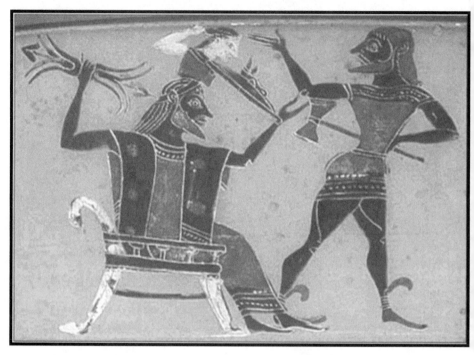

The scene, above, on a large drinking cup from ca. 560 BC depicts the birth of Athena. Hephaistos, carrying his axe, walks away but twists his upper body back to look at Athena after playing his part in her birth. Zeus grasps the lightning bolt as Athena emerges fully-armed.

Her birth is the theme of the sacred east pediment of her famous temple, the Parthenon. In *Athena and Eden*, I summarize her birth thus:

Athena's coming into being out of Zeus is a marvelously concise picture of the key event—the world-shaking event—in Eden. Zeus is a picture of Adam as "the father of gods and men." Eve came out of Adam. Athena, the Greek Eve, came out of Zeus, a deified picture of Adam. Athena's coming into being out of the head of Zeus also signifies that she is the brain-child of the transfigured serpent. The age in which we live, the age initiated by the Greeks, is a new postdiluvian age, a new beginning, a new system which exalts Eve's wisdom in eating the fruit of the tree in the Garden, a wisdom with the power to establish the foundation of a human culture lasting thousands of years. Athena, the new Eve, is fully-armed to fight for the Greek religious system, and for the city that bears her name.

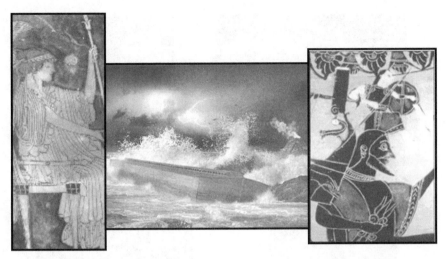

Eve's seed, the Book of Genesis said, would bruise the head of the serpent. Noah, a righteous seed of Eve, figuratively did just that by surviving the Deluge which destroyed the entire line of Kain. After the Flood, with the line of Kain reestablished, Athena, the serpent's Eve, made certain the curse of Genesis could not operate in the Greek age, for she would remain Athena Parthenos, Athena the maiden, Athena the virgin without offspring. There is no seed of this woman to crush the serpent's head in the Greek age. Yahweh's curse is thus broken, and the serpent's promise to Eve—"Ye shall not surely die"—is made manifest, for Athena is A-thana(tos), the deathless one.

The above images help put Athena's birth in its historical perspective. Hera, the sister/wife of Zeus and the original goddess of childbirth and marriage, came first. She represents the primal Eve. By birth alone, Hera holds the scepter of rule. She didn't have to do anything to earn it. Being the motherless mother of all humanity was enough to make her queen of Olympus. Then came the Flood which wiped out the line of Kain.

For several generations, Noah and the line of Seth ruled. The line of Kain had to do battle to reestablish itself, and the reborn serpent's Eve had to emerge ready for that battle. And so Athena is pictured as coming out full-grown and fully-armed, carrying not a scepter, but a spear. Her birth full-grown out of Zeus is a picture of Eve's original full-grown birth out of Adam.

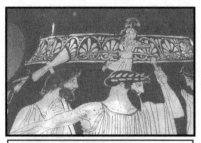

Rebirth of the serpent's Eve

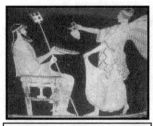

Poseidon replaces Nereus

Hermes becomes prophet of Zeus

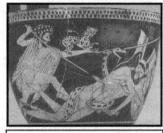

The gods defeat the Giants

The rebirth of the serpent's Eve, the central event in Greek myth, does not occur in a vacuum; it fits into a context. Context comes from the Latin *con-texere*, meaning together-weave. Greek mythology is a product of ancient poets and artists weaving together various events in their history with a common theme—the reestablishment of the way of Kain after the Flood.

To get some perspective on how the Greeks looked back on the development of their religious system, let's go back to a more recent momentous change in history with which most of us are familiar—the American Revolution. We think of Paul Revere's ride. We think of Ethan Allan and his Green Mountain Boys. We think of the Boston Tea Party and Valley Forge. We think of the surrender of Cornwallis at Yorktown. The common theme to these events is the victory of the American colonists and the defeat of the British. Many related events chronicle the success of the American Revolution. So also do many related events chronicle the success of the Greek religious system—the victory of the way of Kain over the way of Seth after the Flood. And they all happen at the same time, or within the same general time frame. Here are some of those events

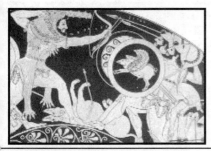

Herakles overcomes three-bodied Geryon

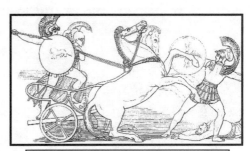

Athena helps Diomedes wound Ares

Herakles returns to the Garden

The line of Kain reborn

which, when woven together, define the essence of Greek mythology:

- The birth of Athena—the rebirth of the serpent's Eve.
- Poseidon takes the place of Nereus/Noah (chapter 8).
- Hermes, the Cush of Babylon, embraces the serpent's system (chapter 12).
- The gods defeat the Giants—the Yahweh-believing sons of Noah (chapter 15).
- Herakles kills Geryon who represents the authority of the three sons of Noah (chapter 14)
- Athena inspires Greek heroes to wound Ares/Seth and kill his offspring (chapters 5 and 14).
- Herakles returns to the serpent's tree and obtains the sacred fruit for Athena (chapter 14).
- The seed of Hephaistos/Kain is reborn from the earth in Athens (chapter 16).

Let's keep this unity and interconnectedness of Greek mythology in mind as we proceed.

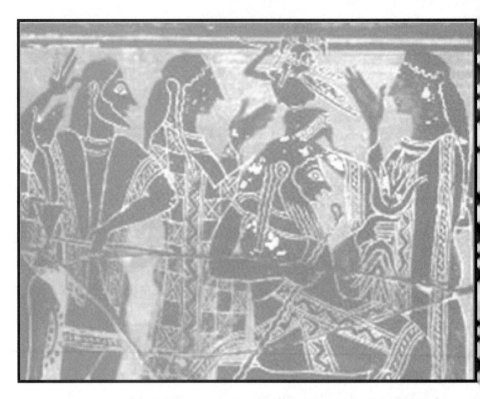

On the above vase from about 570 BC, Athena emerges from the head of the seated Zeus. In his left hand he holds a flaming lightning bolt; in his right, a scepter of rule: the serpent's enlightenment rules. Athena wears her helmet and holds her shield and spear. She emerges fighting on behalf of the serpent's system. To either side of Zeus stand the goddesses of childbirth, each wearing a patterned dress and raising one hand in the air. These are daughters of Hera, sister/wife of Zeus and the chief goddess of childbirth. Behind the goddess of childbirth to our left stands Hephaistos in winged boots, holding his double axe.

On the vase, opposite, from about 525 BC, Zeus is again attended by Hera's daughters, the goddesses of childbirth. Hephaistos, with his axe, stands to our right this time.

Let's examine the role of Hephaistos in the birth of Athena. In about 500 BC, Pindar wrote, "by the skills of Hephaistos with the bronze-forged hatchet, Athena leapt from the top of her father's head and cried aloud

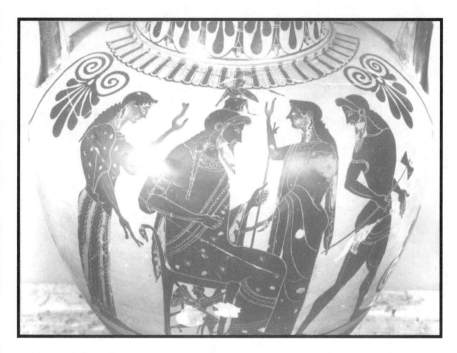

with a mighty shout." Many artists from the Archaic and Classical periods put Hephaistos and his axe in Athena's birth scenes, but he is never seen hitting the head of Zeus, and Zeus never shows any bad effects. But then Apollodorus, who wrote an uncritical summary of Greek mythology in about 140 BC opined, "*Hephaistos smote the head of Zeus* with an axe, and Athena, fully-armed leaped up from the top of his head." Apollodorus' unwarranted assumption (italicized), is where the idea that Hephaistos struck Zeus in the head comes from. The leaves of time drop stealthily, and sometimes they obscure the meaning of a myth.

I believe Pindar's phrase "by the skills of Hephaistos with the bronze-forged hatchet" refers to Kain's killing of Abel. That is the original vicious and violent act that set in motion "the way of Kain" and eventually led to the outright welcoming of the serpent's enlightenment. Why bring Hephaistos, the deified Kain, into the birth-scene if that's not the case? I believe the vase painters are telling us that this new beginning—the rebirth of the serpent's Eve—is based on the old beginning of this religion's spiritual standpoint somewhere east of Eden.

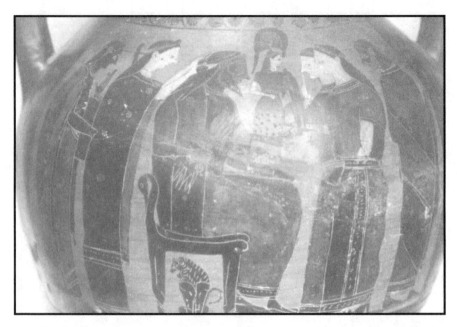

The above storage jar from ca. 525 BC depicts the birth of Athena. Zeus sits holding lightning bolts in his right hand as a sign of the moment of lighting up in paradise. Athena has emerged with spear and shield and stands on his lap facing the two goddesses of childbirth. I haven't been able to identify the figures behind Zeus, but the old man to our right facing Athena and Zeus is Nereus, the Greek Noah.

The lion under Zeus' chair is a symbol of kingship or rule, and that is what the painting is about. The artist has made Nereus a witness to the rebirth of the serpent's Eve which, of course, means an end to his rule and an end to the dominance of the line of Seth. Athena may be the nemesis of Nereus, but she is not going to hurt him physically: she and her Zeus-religion are going to take over from him spiritually.

On the storage jar opposite from ca. 550 BC, the two goddesses of childbirth assist the seated Zeus who holds the lightning bolts. This time it is a swan under the chair. Athena emerges from Zeus with shield and spear confronting Ares who is most certainly not here to help with the birth. Athena hates Ares, and Ares hates Athena. In Homer's *Iliad* Ares, speaking to Zeus, calls Athena a "mad and baneful maid, whose mind is

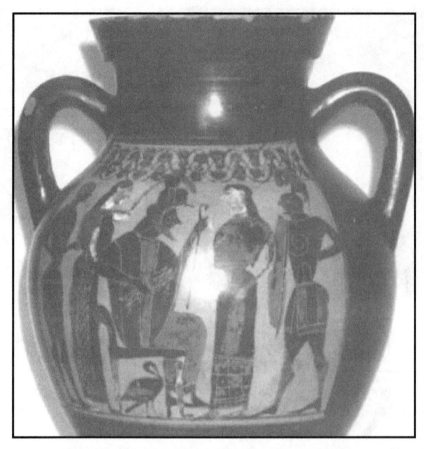

ever set on deeds of lawlessness." Zeus has summoned his "pestilent" and "renegade" son, "the bane of mortals" to witness the birth of the goddess who, as we shall see in Chapter 16, will become the foster-mother of the line of Kain, and put Ares/Seth in his subordinate place. Athena will hurt Ares, and inspire Herakles and other heroes to kill his children.

The swan is a symbol of Zeus' generative spiritual power, for in the guise of a swan, he "fathered" such famous offspring as Helen (of Troy) and the twin, Polydeukes. One artist puts Nike under Zeus' chair during the birth; another puts a sphinx there. Nike symbolizes the victory of Zeus-religion which Athena's birth brings about. The sphinx (female head, lion body, eagle wings) alludes to the original mother, Eve, with power on earth and in the heavens.

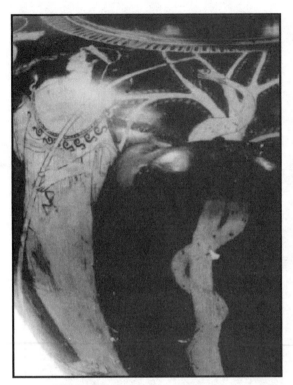

Athena's familiar and endearing intimacy with the serpent is undeniable, and it points straight to Eden. Her being is indissolubly coupled with the serpent: she is the goddess of the serpent's wisdom. Above, in this rare and revealing partially damaged vase-painting, Athena, identified by her serpent-trimmed aegis and spear, stands proudly by the tree. The serpent appears to be giving her instructions.

Plato wrote that Athena had "the mind of Zeus," and we know Zeus to be the transfigured serpent. Above top, we see the head of Athena from one of her temples more ancient than the Parthenon. Her crown, a symbol of rule, is a crown of serpents. On that same statue, above center, Athena's aegis, as almost always, is serpent-trimmed. In the center of that aegis glared the Gorgon Medusa—the head of serpents. The huge serpent that rises up next to her inside her shield on her Parthenon idol-image is her best friend. There is no doubt that it is the serpent who ordains Athena's sovereignty and rules her thinking.

Let me suggest that the notorious "mother of the prostitutes" mentioned in the Book of Revelation is Athena. Here are verses 17:3-5, which describe a vision of the apostle John:

And I perceived a woman sitting on a scarlet wild beast replete with the names of blasphemy, and having seven heads and ten horns. And the woman was clothed with purple and scarlet, and gilded with gold and precious stones and pearls, having a golden cup in her hand, brimming with abominations and the uncleannesses of the prostitution of her and the earth. And on her forehead is written a name:

<div align="center">

Secret
Babylon the Great
the mother of the prostitutes
and the abominations
of the earth.

</div>

The prostitution of the woman is not literal, but figurative. She is *spiritually* unfaithful and wanton. And the "mother of the prostitutes;" that is, the mother of all the spiritually unfaithful, is Eve at the moment she disbelieved God and instead believed the serpent.

The woman is sitting on "a scarlet wild beast." The scarlet color associates the wild beast with riches and rule. The Greek word translated "wild beast" is *therion*. In Acts 28:4, a serpent came out of some kindling and fastened onto Paul's hand. It is identified in that passage as a "wild beast" (therion). So the woman sits upon the serpent, which is the basis of her power. The woman sounds like Athena, and the final verse of Chapter 17 seems to confirm it:

"And the woman whom you perceived is the great city which has a kingdom over the kings of the earth."

The woman, Athena, is the city, Athens; and the kingdom over the kings of the earth is a cultural kingdom.

Now it really gets interesting. This written name (the woman's identity), including the fact that it is secret, appears on the woman's forehead. The Greek word for forehead is *metopon*, nearly identical to the word metope that we use to describe the nearly-square sculptures on certain

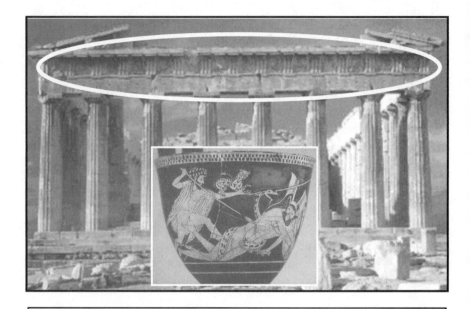

Above, the east façade of the Parthenon as it looks today. The pediment de-
picted the birth of Athena—the rebirth of the serpent's Eve after the Flood.
The fourteen metopes below it depicted the gods (Zeus-religion) defeating the
Giants (the Yahweh-believing sons of Noah). The inset is a vase-painting of a
god killing a Giant. Similar scenes filled the metopes which may represent
Athena's forehead according to the Book of Revelation.

Greek temples. The Parthenon has a total of ninety-two metopes, with
fourteen under the east pediment, which is the front, or forehead, of the
building. Athena's idol-image faced this direction. These fourteen
metopes depicted the gods defeating the Giants, which as we shall see in
Chapter 15, is a picture of the Greek religious system overcoming the
righteous (Yahweh-believing) sons of Noah.

In the sight of the Creator, this is one of the main abominations, if not
the chief abomination, of all "the abominations of the earth." Jesus said
to the unbelieving Pharisees in Luke 16:15: "You are those who are justi-
fying yourselves in the sight of men, yet God knows your hearts, for
what is high among men is an abomination in the sight of God." The
Greeks had elevated their idol-image of the serpent's Eve and her temple
to the highest place in their city and memorialized the defeat of the Yah-

weh-believing sons of Noah in marble on the forehead of her temple. They elevated the serpent and the serpent's system above the Creator of all things in heaven and earth.

The right hand of her Parthenon idol-image, above, holds Nike, which represents both the serpent's victory in the Garden of Eden and the victory over the sons of Noah. Yahweh had condemned the serpent to crawl on its belly, yet all who entered the Parthenon to worship or admire the great statue were forced to look up to both Athena and the serpent. That

certainly fits the theme of Revelation 17:3-5. But what of the golden cup said to be in the hand of "the mother of the prostitutes"?

Athena is pictured on several vases, as on the one above from ca. 480 BC, pouring from her cup into Herakles' wine-drinking cup. This is a great celebration. Herakles is the Athena-led enforcer of Zeus-religion. He wounds Ares and kills his sons and daughters. He forces Nereus (Noah) to tell him the location of the serpent's apple tree. He helps the gods defeat the Yahweh-believing sons of Noah. He slays the triple-bodied Geryon who represents the power of Noah's three sons. Athena rewards Herakles for all this and more by pouring him wine from the golden cup which is figuratively "brimming with abominations and the uncleannesses of the [spiritual] prostitution of her and the earth."

"Babylon the Great" refers to the place of origin of the serpent-centered and man-centered religion that the Greeks embraced. Hermes, the Cush of Babylon, is the chief prophet of Zeus-religion. We'll learn more about him in the next chapter.

Chapter 12
Hermes—The Deified Cush from Babylon

Hermes is the deified Cush from Babylon. He is the original prophet of Zeus-religion, the one who orchestrated the return of the serpent's system after the Flood.

Kekrops, the half-man/half-serpent, who brought the serpent's system to Athens, sacrificed to Hermes, looking to him as his guide and mentor.

Hermes and the Tower of Babel.

Here is a passage concerning Hermes from Acts 14:8-13:

And a certain man in Lystra [a city in Asia Minor], impotent in the feet, sat there, lame from his mother's womb, who never walks. This one hears Paul speaking, who, looking intently at him, and perceiving that he has faith to be saved, said with a loud voice, "Rise upright on your feet!" And he leaps, and walked.

Besides, the throngs, perceiving what Paul does, lift up their voice in Lycaonian, saying, "The gods, made like men, descended to us!" Besides, they called Barnabas Zeus, yet Paul, Hermes, since, in fact, he was the leading speaker. Besides, the priest of the Zeus which is before the city, bringing bulls and garlands to the portals, wanted to sacrifice together with the throngs.

The ancients viewed Hermes as "the leading speaker" of Zeus. He is the chief prophet of Zeus-religion. The literal meaning of Hermes is "Translator." This points us directly to Babylon and the Tower of Babel, where the tongues of mankind were divided, and from then on, an inter-

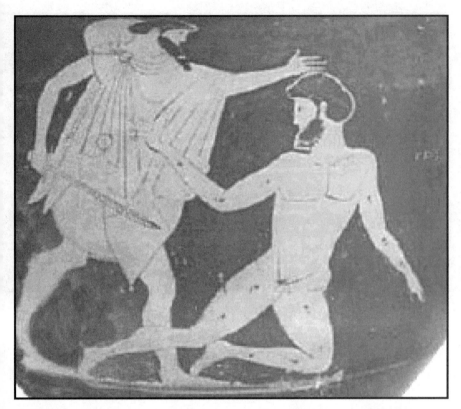

preter, or translator, was required. On the inset picture, opposite, Hermes wears his *petasos*, or traveling cap. Hermes traveled around the ancient world spreading Zeus-religion. He also carries his *kerykeion*, or herald's staff (*caduceus* in Latin). The kerykeion features a serpent with two heads facing each other symbolizing the serpent's rule over the past and the future.

The above vase from about 475 BC summarizes the historical role of Hermes, so far as the Greeks were concerned. Hermes is slaying a man called *Argus Panoptes*, whose name meant the "Bright One of All Eyes." On the vase, he is pictured with eyes all over his body. He is a representative of the All-Seeing God of Noah. The artist is showing us that Hermes, the deified Cush of Babylon, succeeded in eliminating the power and influence of the Yahweh-believing sons of Noah who worshipped the All-Seeing God.

The vase paintings on these two pages tell the story of Hermes' ambition from beginning to end. Remember that Hermes is the deified Cush from Babylon. He is the son of Ham and grandson of Noah. And he is the father of Nimrod who in the Greek world became the great hero, Herakles. The above action takes place several generations after the Flood. The Kentaur Chiron represents Noah and his line just prior to the Flood and for an extended period after it. He may even represent Cush's father, Ham. Over his left shoulder, he carries a branch, a regular attribute, identifying him as part of that "strange branch" of humanity—the line of Seth. Cush flees with his son, Nimrod, from the authority of Noah to reestablish the way of Kain. In Greek terms, Hermes flees with his son, Herakles, to establish Zeus-religion.

Hermes and Herakles are both named on the vase. Chiron wears a long beard, a sign of age and wisdom. His human front legs make him a benign Kentaur concerned with the fate of his offspring. His pose and open-palmed gesture with his right hand suggest a combination of consternation and sadness at Hermes' departure.

But what end does Hermes have in view? Where does he imagine that his running from the line of Seth will lead?

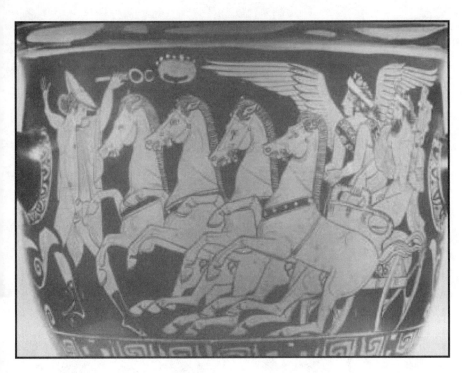

We find the answer on the above vase from the Classical period. Hermes, to the left, the deified Cush from Babylon, rejoices as Nike drives the victorious chariot of Herakles. As we shall see, Herakles, the Nimrod of Genesis, will play an indispensable role in the victory of the gods over the Giants, which is the Greek way of portraying the great victory of Zeus-religion over the Yahweh-believing sons of Noah. Nike's presence in these so-called "mythological" scenes always has to do with the victory of the transfigured serpent's system over the line of Seth.

Hermes looks like a football fan who is signaling ecstatically that his team has just scored the winning touchdown. That is the very spirit of this vase scene. Gesture and gaze play important parts in Greek paintings. Nike and Herakles are looking directly at Hermes. They are taking their cue from him, for he is the chief prophet of Zeus-religion. I just realized that Hermes isn't merely a fan: he's the happy and successful coach of the Zeus-religion team. This victory is the end he had in view when he ran away from Chiron with his child Herakles.

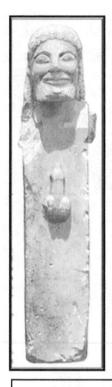

A Herm and Peter Connolly's painting of the Athenian Akropolis.

According to Genesis 11:4, those who erected the Tower of Babel revealed their motive when they said, "Build will we for ourselves a city and a tower with its head in the heavens, and make for ourselves a name." Known as Hermes in the Greek world, Cush made a great name for himself. Herms like the one pictured above appeared almost every-where (See Chapter 10 of *Athena and Eden*). The most famous Herm in Athens stood at the entrance to the Akropolis where the sacred precinct began. The ancient travel writer, Pausanias, wrote that a revered wooden Herm stood in a temple on the Akropolis itself. Both of these Herms pointed to the fact that the religious rites performed on the sacred rock of Athens owed their origin to Hermes, the deified Cush of Babylon.

At the highest point of their city, the Athenians built a temple, and inside it, a gigantic gold and ivory image elevating Eve to the status of a great and immortal goddess because she had defied the Creator and given

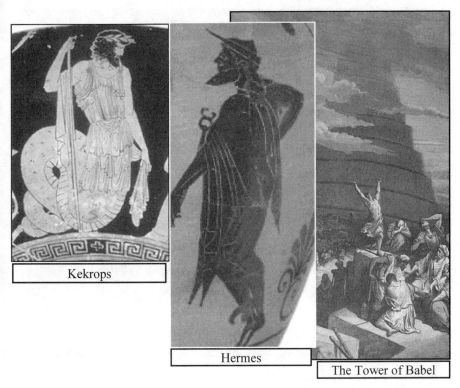

Kekrops

Hermes

The Tower of Babel

to mankind the knowledge of good and evil. And they adored Hermes on their sacred rock for bringing them Zeus-religion. In Babylon, mankind built a city and a tower; in Greece, mankind built a city and elevated temples. Both cities expressed the same idea: man, not God, is the measure of all things.

The legendary first king of Athens, the half-man/half-serpent (the serpent's man) Kekrops, sacrificed to Hermes. This means that he looked to Hermes as his religious guide. The fact that Kekrops looked to Hermes and Babylon makes perfect sense. That's where the belief structure of Zeus-religion originated. A Greek legend tells that Hermes married a daughter of Kekrops. This may or may not be literally true; it may mean that Hermes figuratively became Kekrops' son-in-law; that is, Kekrops and the Athenians welcomed Hermes and his religious standpoint into their family. Hermes is the "Translator" from the Tower of Babel. Zeus-religion is the spiritual philosophy of Hermes, translated into Greek.

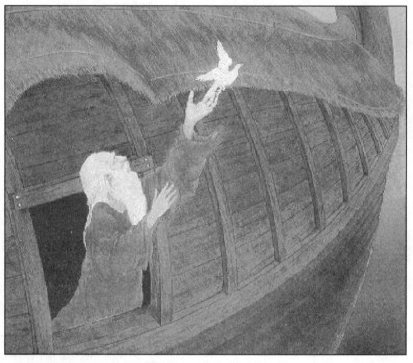

We read this in Genesis 8:8-12:

And sending out is [Noah] a dove . . . to see if the waters are slight over the surface of the ground. Yet not find does the dove a resting place for the sole of her foot, and she is returning to him to the ark, for the water is on the surface of the entire earth. And stretching forth is he his hand and taking her, and is bringing her to him into the ark.

And waiting is he further another seven days. And proceeding is he to send out the dove from the ark. And coming is the dove to him at eventide, and behold! A torn-off olive leaf is in its beak! And knowing is Noah that the waters are slight above the earth.

And waiting is he further another seven days, and once more is sending out the dove, yet not any more to return to him further.

Thus the olive tree and the dove became symbols of the new human age after the Flood. Greek artists knew this—it was part of their racial memory. Part of Zeus-religion's claim to legitimacy was the possession of these symbols.

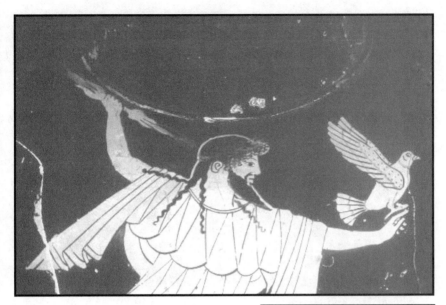

That helps us understand these two vase depictions. On the one above from ca. 465 BC, Zeus holds the lightning bolt in his right hand while the dove perches on his left. Then on the bizarre vase to the right from ca. 440 BC, Hermes' phallus stretches across a flaming sacrificial altar as the dove lands on it. By perching the dove on Zeus' hand and on the phallus of Hermes, the artists are telling us that the spirit of this post-Flood age belongs to Zeus, the supreme god of Greeks, and to

the seed of his chief prophet, Hermes, the deified Cush, who was the one who defined their system of worship and sacrifice.

The Greeks pushed Nereus, their version of Noah, out of the way and replaced him with Poseidon, the brother of Zeus. In the process, Athena took the olive tree and presented it to the people of Athens as if it had been hers all along. Zeus and his prophet Hermes took possession of Noah's dove, as if it had been theirs all along, also.

Above, Iris and Hermes on an oil jug from ca. 490 BC. These were the only two "official" messengers of Zeus, both carrying the kerykeion. Zeus usurped for himself Iris, the rainbow, as a sign of his relationship with mankind. Zeus-religion claims the dove, olive tree, and rainbow.

Iris dates back to the Flood in Greek myth and in Genesis (as Yahweh's rainbow). Hermes/Cush became the messenger or prophet of Zeus two long generations later. On the drinking-cup fragment, below, from 450 BC, Iris presents the child Hermes to Zeus.

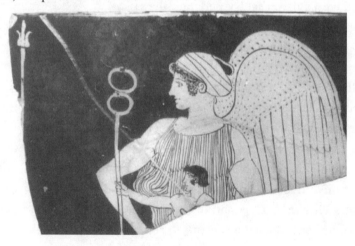

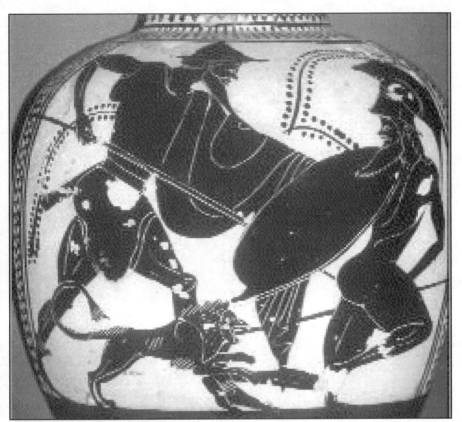

On the above vase from ca. 490 BC, the artist shows Hermes, accompanied by a lion, in the process of killing a Giant. As we shall see in chapter 15, the Giants represented the Yahweh-believing sons of Noah. The lion, left, is a symbol of ancient Babylon, the place where Hermes, the deified Cush, began his career.

The conquests of his son, Nimrod, enabled Cush to spread the new Zeus-religion rapidly. The Greeks called Nimrod Herakles and adopted him as their great hero. In the next two chapters, we'll see why he appears on more extant Greek vases than any other figure.

Chapter 13
The First Seven Labors of Herakles

Herakles is the great hunter and warrior from Genesis: Nimrod, transplanted to Greek soil. He was the first man after the Flood to organize armies, build walled cities, and protect men and women from the roaming wild beasts.

In the first seven of his twelve labors, Herakles demonstrates that he is a master of the animal-world, striking fear into the beasts of the land, the creatures of the sea, and the birds of the air.

The labors of Herakles contain clear reminiscences of an earlier Mesopotamian tradition that connects directly to the great hunter and conqueror, Nimrod, in Genesis. Archaeological evidence from that region shows that the figure of Herakles/Nimrod is found as early as the middle of the 3rd millennium BC. On the Assyrian seal impression from the 9th century BC, above left, we see the Assyrian king in single combat with a lion. Above right, on an 8th century BC tripod from Athens, it is now Herakles who kills the lion.

Nimrod was the great-grandson of Noah, the grandson of Ham, and the son of Cush. We read in Genesis 10: 8-9:

And Cush generates Nimrod. He starts to become a master in the earth. He becomes a master hunter before Yahweh Elohim. Therefore is it being said, "As Nimrod, the master hunter before Yahweh."

After the Flood, God's powerful operations remained fresh in the minds of humanity. For a considerable period of time, the descendants of Noah were content to live on the same level with their neighbors, and though every man bare rule in his own house, no man pretended any further. That changed with Nimrod who was determined to lord his great strength and cunning over his neighbors.

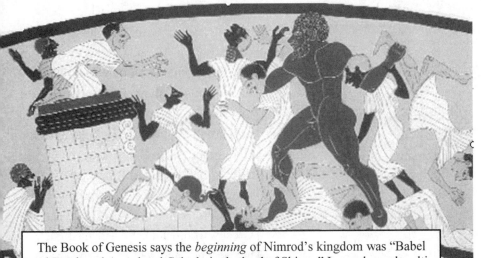

The Book of Genesis says the *beginning* of Nimrod's kingdom was "Babel and Erech and Accad and Calneh, in the land of Shinar." Legend says he ultimately conquered the known world. On the Greek vase, above, from the Archaic period, an artist shows Herakles conquering the Egyptians.

Nimrod became a great hunter and benefactor of the men and women who were terrified by roaming wild animals after the Flood. This required great courage and adroitness, and thus gave an opportunity for Nimrod to command others, and gradually attach a number of devoted followers to himself. From such a beginning, Nimrod began to rule, and to force others to submit. He invaded his neighbors' rights and properties, and persecuted innocent men, endeavoring to make all his own by force and violence. These were the same things Herakles did.

Nimrod was the first to organize an army, build walled cities, and establish himself as king. Not content with delivering men from the fear of wild beasts, he set to work also to emancipate them from the fear of Noah's God. Even as eagle-winged and bold as Nimrod's ambitions were, ultimately his accomplishments in life dwarfed them.

The Assyrian tradition and Genesis make Nimrod the first great hunter/warrior after the Flood. The Greek tradition calls that man Herakles. Herakles' given name was Alcaeüs which means "Mighty One." Herakles and Nimrod are the same historical figure seen through different cultural lenses. Let's look through the ancient Greek cultural lens.

 The ancient Greeks fit the labors and conquests of Herakles into their own religious context. As they told the story of his exploits, they simultaneously told the story of Hera's receding into the background, and of Athena's rise as the chief goddess in the Greek pantheon. They did this by infusing Hera with a hatred for Herakles, for she knew that when he completed his labors, the Greeks would look to Athena first, and her second; and they did it by infusing Athena with a love for Herakles, so that every step of the way she was there to protect him not only from beasts and human enemies, but from the envy and bitterness of Hera as well.

As a picture of the primal Eve and mother of all humanity, Hera was part of the old order before the Flood; Athena was a picture of the re-born serpent's Eve after the Flood. The name Herakles means the "Glory of Hera" and it refers to the "fading glory of Hera" that his labors chronicle. Each new success of Herakles brings the rule of Athena and the final victory of the new Zeus-religion closer.

Above, on a vase from ca. 475 BC, Herakles, in his crib, gains control of the snakes sent by Hera to kill him. Athena extends her protective arm over the crib while Alkmene, Herakles' mother, pulls Herakles' twin brother, Iphikles, to safety. It is important to understand that Hera's hatred wasn't real: it was a literary and artistic device used to explain real history. As Hera, the wife of Zeus and the primal Eve, fades into the background, Athena, the guide and protector of Herakles, gains ascendancy. The poets and artists used Hera's resentment to put Herakles' labors into their true historical context.

The way the Greek artists and story-tellers wove together, throughout his labors, Hera's hatred of Herakles and Athena's successful protection of him, is nothing short of brilliant.

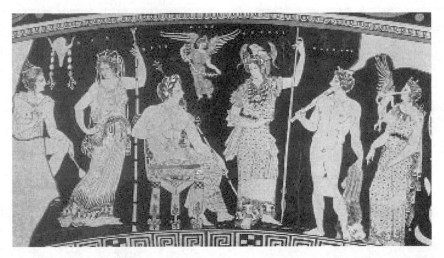

I discuss the above vase depiction from the Classical period in *Athena and Eden*, and because of the great clarity it brings to us, I summarize it here. Greek poets mentioned Hera's resentment, and here the Greek artist portrays it; and in the process, tells us a profound and detailed story in one simple scene. It depicts the time when Herakles, his labors complete, enters Olympus as his reward.

To the right, the now immortal Herakles, with his club slung over his shoulder and holding his lion skin, appears naked and unashamed as he looks to his gods and patrons, Athena and Zeus. Next to Herakles stands his wife Hebe, or Youth. An *erotes*, a symbol of erotic love, hovers between them indicating their happiness. Herakles stands next to his protectress Athena, and looks toward her and the seated Zeus. Nike hovers between Zeus and Athena attesting to their victory—a victory with which Herakles is integrally and essentially related.

Hera, hand-on-hip at the far side of the scene from Herakles, looks away from Athena and Zeus (who has turned his back on her), and toward Hermes with a glare of anger and blame. She is right to be mad at Hermes, the deified Cush from Genesis, for he is the chief messenger of Zeus who is largely responsible for the new order of Zeus-religion after the Flood, an order that pushes Hera into the background. With this end in view, let's take a look at Herakles' labors one by one.

On this vase depiction from ca. 490 BC, Herakles breaks the neck of the lion of Nemea with his bare hands.

Herakles' first labor was the killing of the lion of Nemea. Edward Tripp writes of it:

On his way to Nemea, Herakles spent a night at Cleonae in the hut of a day laborer named Molorchus. Molorchus, who had evidently never encountered such a formidable man as Herakles, offered to sacrifice to him. Herakles told him to wait for thirty days. If by this time he had not returned, Molorchus might sacrifice to him as a hero. If he did return, the sacrifice should be offered to Zeus the Savior.

Right away we learn Herakles' religious standpoint: he worships Zeus. Edward Tripp continues the story:

Herakles then proceeded to the two-mouthed cave that was the lion's lair. He had no trouble in finding the beast or, since his aim was infallible, in shooting it; but, when his arrow bounced harmlessly off the lion's pelt, he realized that it was invulnerable to weapons. He therefore blocked up one end of the cave and strode in, unarmed, at the other mouth. Meeting the

animal face to face, he strangled it with his bare hands. On the thirtieth day of his waiting period Molorchus looked up from his preparations for a hero-sacrifice and saw Herakles approaching with the dead lion slung over his shoulder. Dutifully he switched to the more elaborate rites due a god.

Herakles' very first labor puts him within the framework of a religious system. Molorchus recognizes him as a hero, and sacrifices to Olympian Zeus when he returns. To kill such a fierce lion bare-handed, Herakles must have the power of Zeus with him!

Herakles dressed himself in the pelt, with the lion's scalp serving as a kind of hood. Above, on a vase from ca. 525 BC, we see him wearing it. Artists used his lion pelt and his club to identify him in vase scenes, and in sculpture. He killed the king of the beasts using only his courage, his mind, and his hands as weapons; and thenceforth, he boasted of possessing the leonine powers with which he terrified and stalked his enemies.

The killing of the lion of Nemea gets everyone's attention. That's why it is first in the official canon of his twelve labors. Once Herakles became known as the hero who killed the king of the beasts with his bare hands, his reputation swelled like a dry sponge in water.

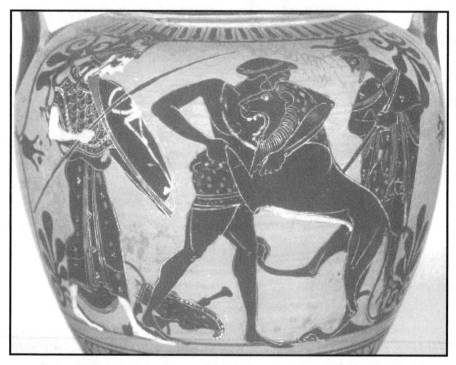

Most vase scenes involving Herakles, such as the one above from ca. 510 BC, put him within a religious context. The artist depicts Herakles wrestling the roaring Nemean lion, bracketed between Athena and Hermes who, from the standpoint of Scripture, represent the reborn serpent's Eve and Zeus' prophet, Cush, from Babylon.

Athena wears her aegis and a high-crested helmet, and moves toward Herakles with her spear and shield which has a white tripod as an emblem. The tripod is associated with Apollo's temple at Delphi as a symbol of what the future holds. This is Herakles' first labor. By the time he has completed all twelve, Zeus-religion will rule the Greek world and its future. Athena and Hermes look to Herakles as the hero and king of humanity who, through his conquests and labors, will restore the serpent's system, and bring back the way of Kain.

Hermes wears winged shoes and carries his kerykeion. Both this wand with serpent heads at the end of it and Athena's aegis, or goat skin, are signs of the authority of Zeus.

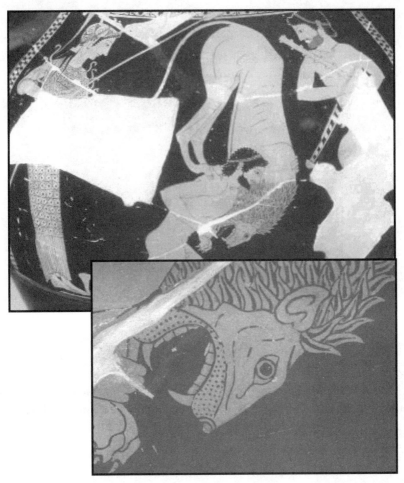

On the above partially damaged vase depiction from ca. 520 BC, a nude Herakles fights the Nemean lion, grasping the ferocious beast's forepaw with his right hand and its shoulders with his left arm. The lion digs its hind paws into Herakles' shoulders, as it is being slung to the ground where Herakles will break its neck. Athena stands by, wearing her serpent-fringed aegis. The other figure is Herakles' nephew, Iolaüs.

After examining the literary sources and the many detailed vase-paintings and sculptures, it is undeniable that a man as strong, as fierce, and as courageous as Herakles once lived. The Nimrod of Genesis passed into the Greek collective cultural memory as Herakles.

Genesis 9:1-3 reads:

And blessing is the Elohim [God] Noah and his sons. And saying is he to them, "Be fruitful and increase and fill the earth and subdue it."

"And the fear of you and dismay due to you shall come on every living animal of the earth, even on every flyer of the heavens, and in all which is moving on the ground, and in all the fishes of the sea. Into your hand are they given."

This is the mandate from God to subject all the animals of the earth, on land, sea, and air. Herakles has already conquered the lion, the king of the beasts on land. As his second labor, Herakles kills the powerful and hideous many-headed creature called the Hydra, pictured above on a vase from the Classical period. Hydra means "Sea Creature." In his third labor, Herakles will destroy the vicious Stymphalian birds, thus fulfilling mankind's call to dominate the animal life on earth—land, sea, and air.

There is one animal that Herakles does not subject to the rule of mankind, and that one animal is the serpent. Instead of ruling over the serpent as per God's instructions to rule over "every living animal," Herakles subjects himself to the serpent's power. He worships, or looks up to with

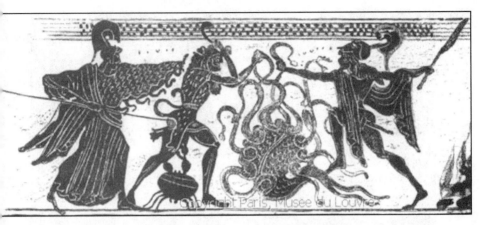

adoration, Zeus, Athena, and Hermes. Zeus is the transfigured serpent. Athena represents the rebirth of the serpent's Eve. She wears a serpent-fringed aegis with the Gorgon Medusa, the head of serpents, on it. Hermes, the chief messenger of Zeus, carries as a symbol of the source of his authority a kerykeion, a staff with facing snake heads on it. Herakles elevates the serpent and its power, and so while appearing to carry out God's instructions, violates them in the most significant way possible. Herakles takes the mandate recorded in Genesis, but changes its orientation away from God and toward the serpent and the way of Kain. Properly understood, the Greek myths tell us the early history of humanity with marvelous lucidity.

Let's get back to the Hydra. That creature, the half-sister of the lion of Nemea, bred in the lake of Lerna, went forth into the plain and ravaged the cattle and the countryside. The Hydra had a huge body, with nine heads, eight mortal, but the middle one supposedly immortal. On the above vase depiction from ca. 500 BC, we see Herakles and his nephew, Iolaüs, cutting off the Hydra's mortal heads and searing the necks with fire. A large crab sent by Hera attacks Herakles' legs, but Athena, again supplying the key religious connection, is there to see to it that the hero prevails. Athena guides and guards Herakles when he kills the lion, this sea creature, and the Stymphalian birds. Thus, symbolically, the mastery of "every living animal" is hers—with the exception of the serpent, who masters her and her dutiful servant, Herakles.

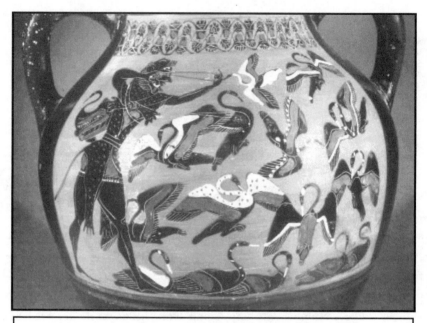

Herakles uses a sling shot against the Stymphalian birds
on a storage jar depiction from ca. 550 BC.

Apollodorus writes that the killing of the Stymphalian birds is the sixth labor of Herakles, but it is more logically his third labor, completing, in order, the hero's mastery of the animals of land, sea, and air.

Let's look at what Apollodorus had to say:

Now at the city of Stymphalos in Arcadia was the lake called Stymphalian, embosomed in a deep wood. To it countless birds had flocked for refuge, fearing to be preyed upon by the wolves. So when Herakles was at a loss how to drive the birds from the wood, Athena gave him brazen castanets, which she had received from Hephaistos. By clashing these on a certain mountain that overhung the lake, he scared the birds. They could not abide the sound, but fluttered up in a fright, and in that way Herakles shot them.

Athena is there to make sure Herakles knows what to do, and Hephaistos, the deified Kain, shows up with the metal implements the hero needs for success. These connections are as important as the accomplishment of the labor itself.

144

Pausanias makes the Stymphalian birds into more formidable foes:

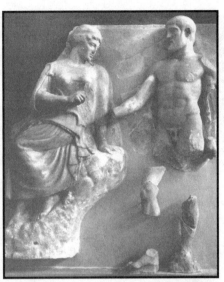

There is a story current about the water of the Stymphalos, that at one time man-eating birds bred on it, which Herakles is said to have shot down. Peisander of Camira, however, says that Herakles did not kill the birds, but drove them away with the noise of rattles. The Arabian desert breeds among other wild creatures birds called Stymphalian, which are quite as savage against men as lions or leopards. These fly against those who come to hunt them, wounding and killing them with their beaks. All armor of bronze or iron that men wear is pierced by the birds; but if they weave a garment of thick cork, the beaks of the Stymphalian birds are caught in the garment, just as the wings of small birds stick in bird-lime.

These birds are of the size of a crane, and are like the ibis, but their beaks are more powerful, and not crooked like that of the ibis. Whether the modern Arabian birds with the same name as the old Arcadian birds are also of the same breed, I do not know. But if there have been from all time Stymphalian birds, just as there have been hawks and eagles, I should call these birds of Arabian origin, and a section of them might have flown on some occasion to Arcadia and reached Stymphalos. Originally they would be called by the Arabians, not Stymphalian, but by another name. But the fame of Herakles, and the superiority of the Greek over the foreigner, has resulted in the birds of the Arabian desert being called Stymphalian even in modern times.

Killing vicious razor-beaked birds seems more befitting the great hero than simply chasing them away with rattles. Let's give the sculptor of the above metope from the temple of Zeus at Olympia the final word. He pictures Herakles handing a dead Stymphalian bird to a very pleased Athena which means, of course, that he killed them.

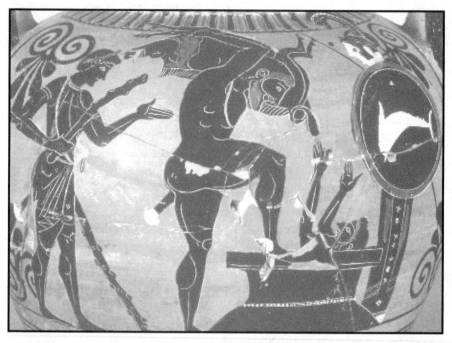

Herakles' fourth labor was the capturing alive of the Erymanthian boar. Most extant vases depict Herakles about to dump the captured beast on his mentor, Eurystheus, who hides in a large jar, as on the above vase from ca. 530 BC. I don't understand why Eurystheus, who has sent Herakles out on this labor, hides from him, or why Herakles threatens to dump the boar on him. The presence of Athena and Iolaüs, the nephew of Herakles, at the delivery are typical of the scene. Athena's presence makes the general statement that she is with Herakles in all his labors and battles, but I don't pick up anything specific.

The boar had been ravaging the countryside, so it fits as part of Herakles'/Nimrod's efforts to protect humanity from ranging wild beasts that had multiplied after the Flood.

During this labor, the Kentaur Pholos entertained Herakles. Pholos set roast meat before the hero while he himself ate his meat raw. The opening of a special wine jar led to a brawl involving other Kentaurs who did not like their community wine shared with Herakles. Herakles killed many of the Kentaurs.

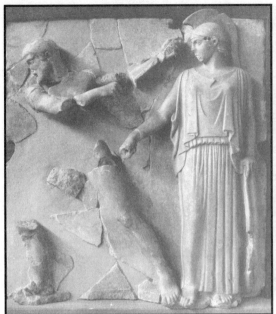
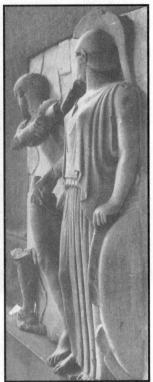

Above and right, we see two views of the Augeian stables metope from the temple of Zeus at Olympia. Athena shows Herakles where to channel the rivers.

For Herakles' fifth labor, he had to remove in a single day the dung of the cattle of Augeias, which had accumulated over centuries. Herakles made a breach in the foundations of the cattle-yard, and then, diverting the courses of the Alpheius and Peneius rivers which flowed near each other, he turned them into the yard, having first made an outlet for the water through another opening, and thus washed away all the dung.

Herakles sought the summit of human attainment, and here we have a vivid and pointed demonstration of what is possible when humanity is aligned with the spirit of the serpent's Eve. The poets didn't mention Athena's role in this labor, but as we can see from the metope above, the sculptors gave her the credit for this great technological feat. On the sculpture itself, I enjoy the way the artist aligned the working arms of Herakles with the directing arm of Athena. He understood his subject— perhaps better than we ever will.

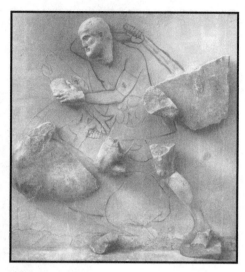

Herakles captures the Kerynitian hind on this partially reconstructed metope from the temple of Zeus at Olympia.

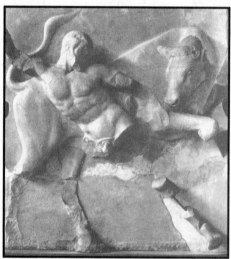

Herakles captures the Cretan bull on this partially reconstructed metope from the temple of Zeus at Olympia.

In his sixth and seventh labors, Herakles continues to demonstrate his dominance over the animal world. He captures the Kerynitian hind, a deer with golden horns (some say a stag, others a doe), and the Cretan bull. Some say this was the bull that fathered the famous Minotaur.

In his final five labors, Herakles turns his attention to the humans who block his way to the Garden of the Hesperides, and the serpent's apple tree in the middle of it. Let's take a look at those labors.

Chapter 14

Return to the Serpent's Tree—Herakles' Last Five Labors

Herakles' last five labors pertain directly to his successful quest for the golden apples on the serpent's tree in the Garden of the Hesperides. During the course of these labors, he learns the location of the Garden from Nereus/Noah, kills sons and daughters of Ares/Seth, overcomes the rule of Noah's three sons, and brings back the serpent from the realm of the unseen. His reward in the Greek religious system is immortality.

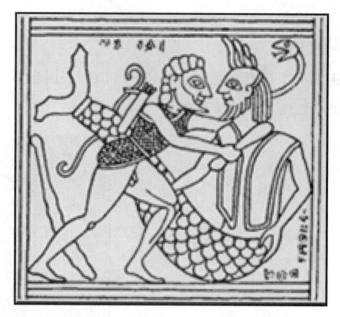

The bronze relief on this shield band panel from 550 BC tells us exactly what Herakles was after—where his labors and conquests were ultimately leading. The inscription identifies the figures as Herakles and *Halios Geron*, the "Salt Sea Old Man," an obvious allusion to Nereus/Noah. His bottom half is a fish, signifying that he came through the great Flood. Herakles demands to know something that only the Salt Sea Old Man can tell him. A flame and a snake come out of Nereus' head. Herakles wants to know where to find the enlightenment of the serpent. According to Apollodorus,

Herakles seized [Nereus] while he slept, and though the god turned himself into all kinds of shapes, the hero bound him and did not release him till he had learned from him where were the apples of the Hesperides.

But it is not an easy road to the serpent's sacred fruit tree in the Garden of the Hesperides. Herakles first has to confront and defeat his spiritual opposition, the sons and daughters of Ares/Seth. And he has to overcome the rule of the three sons of Noah. Then he is free to bring back the power of the serpent to earth, and visit the tree of the serpent's enlightenment for himself.

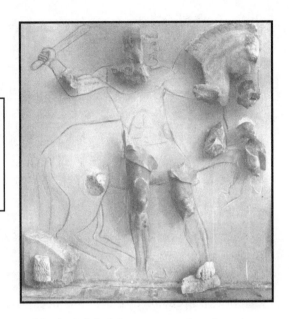

One of the six metopes on the east side of the temple of Zeus at Olympia: Herakles captures one of the mares of Diomedes, a son of Ares.

Apollodorus describes Herakles' eighth labor concerning the capture of the mares of Diomedes thus:

Now this Diomedes was a son of Ares and Cyrene, and he was king of the Bistones, a very warlike Thracian people, and he owned man-eating mares. So Herakles sailed with a band of volunteers, and having overpowered the grooms who were in charge of the mangers, he drove the mares to the sea. When the Bistones in arms came to the rescue, he committed the mares to the guardianship of Abderus, who was a son of Hermes . . . but the mares killed him by dragging him after them. But Herakles fought against the Bistones, slew Diomedes and compelled the rest to flee. And he founded a city Abdera beside the grave of Abderus . . . and bringing the mares he gave them to Eurystheus. But Eurystheus let them go, and they came to Mount Olympus . . . and there they were destroyed by the wild beasts.

Herakles kills Diomedes because he is a son of Ares/Seth. By taking his horses, which represent strength, he overcomes the power of Ares. The mares are destroyed on Mount Olympus, the seat of the Greek religious system. And a city dedicated to a son of Hermes, the prophet of Zeus, is established where the sons of Ares used to rule. This is all about the Greek religious takeover of a certain region.

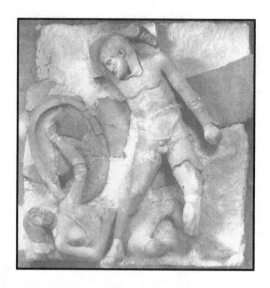

Above, we see one of the six metopes from the west side of the temple of Zeus at Olympia depicting the ninth labor of Herakles. The Greek hero kills the Amazon queen, Hippolyte, in order to get her war belt, a gift from her father, Ares. The belt was a sign of the source of her authority, and a token of her superiority over all the other Amazons. On the vase opposite, from ca. 520 BC, Herakles fights three Amazons.

The reason that Greek heroes had to fight and kill Amazons has eluded scholars for centuries. The answer is very simple: they were children of Ares, that "other" troublesome son of Zeus and Hera, whom we know to be Seth, the youngest son of Adam and Eve, through whom the line of Christ is traced. Unless you see the Ares connection, it seems very puzzling that Athena, a warrior-woman herself, would lead the spiritual fight against the warrior-women Amazons. But when we see that Athena represents the rebirth of the serpent's Eve after the Flood, and that she is the nurturing stepmother of Erichthonios of the reborn line of Kain in Athens, the pieces of the puzzle form a logical mosaic.

According to legend, the Athenians fought a great battle with the Amazons in Athens. The Amazons attacked the Akropolis from a hill northwest of it that became known as the Areopagus—the Hill of Ares.

When the apostle Paul visited Athens, he stood on the Areopagus and

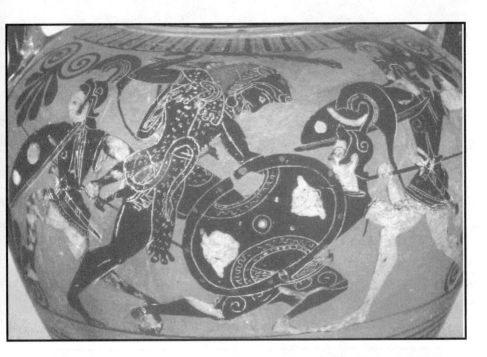

commented on a pedestal he saw which was inscribed, "To an Unknown God." This was the Creator that Greek religion knew nothing of, but to which the line of Seth was devoted. It is worth noting that this little monument did not appear on the Akropolis, the privileged precinct of the line of Kain, but rather on the hill of the god Ares whose offspring, both men and women, Herakles sought to kill. Some Greeks retained a consciousness of the True God. They didn't know His name, but they knew enough to connect him to Ares.

The idea that the Amazons cut off their right breast so that it might not interfere with the use of the bow, and that the name thus means "breastless" is a fable. Amazons are never pictured in sculpture or painting without a breast which they surely would be if that's what their name meant. *Maza* means barley cake. Kain was a "server of the ground" out of which the barley grows. An "a" in front of a Greek word often is the equivalent of our "non" or "un." The Amazons were known as nomadic and not servers of the ground; that is, not those who raise barley and make cakes. A-mazon would thus identity them as not part of the line of Kain.

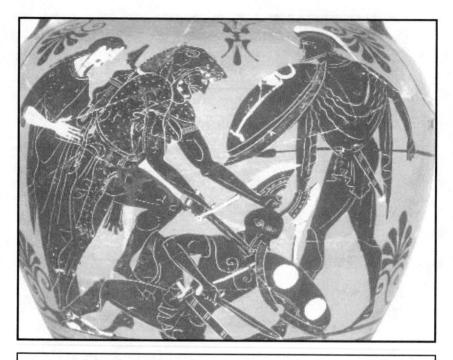

On this black figure neck amphora from ca. 510 BC, Athena's favorite, Herakles, kills Ares' favorite son, Kyknos, as Ares prepares to attack.

Kyknos, the favorite son of Ares, was known to the Greeks as a villain who had robbed the altar of Apollo of its sacrificial victims. This made him a hated enemy of the Greek religious system. Herakles cannot get to the Garden of the Hesperides and the serpent's golden apples with such men as Kyknos blocking his path. For the Greek system to flourish, this great son of Ares must die, and Ares himself must be sent packing. While not in the canon of Herakles' twelve official labors, just about every Greek had heard about this famous fight.

In his *Shield of Herakles*, Hesiod describes Herakles and Kyknos as fighting furiously like two hungry lions facing off on opposite sides of a slain deer, and like crooked-taloned and hooked-beak vultures that scream aloud over a dead mountain goat. I'll tell you the rest of the story based on Hesiod's narration:

Eager to kill the son of Zeus, Kyknos struck the first blow, but Herak-

les deflected it with his shield. Herakles then stuck Kyknos with his spear in that unprotected place in the neck beneath the chin. (See the vase-painting, opposite.) Kyknos fell as an oak falls, and his armor adorned with bronze clashed about him.

Ares, his dark heart filled with rage at the death of his son, sprang at Herakles who faced the god eagerly. Then Athena, wearing her serpent-trimmed aegis, looked at Ares with an angry frown and said, "Ares, check your fierce anger and matchless hands; for it is not ordained that you should kill Herakles, the bold-hearted son of Zeus, and strip off his rich armor. Come, then, cease fighting and do not withstand me."

Angry blood burned in Ares' face. He ignored Athena and rushed headlong at Herakles throwing his spear. Athena reached out from her chariot and turned aside the force of the weapon; and as Ares drew his sword, Herakles shrewdly tore deep into the flesh of Ares' thigh with a spear thrust that cast him flat upon the ground. Ares' charioteers lifted him into his car and drove him away to the safety of Olympus.

That story, relatively unknown today, captivated the Greeks for centuries. Although we can only see half of it, Ares' shield device is a tripod. The python priestesses at Apollo's temple at Delphi sat on such a tripod overtop a fuming abyss as they endeavored to discern the future. The vase artist is letting us know what is at stake here—the religious future of the Greek world.

Herakles couldn't kill Ares because he was a god from before the Flood—that strange and hated son of Zeus and Hera. But with the help of Athena, Herakles could wound him, and drive him back to a place where his influence on the human realm would remain minimal. In the middle of the vase depiction, a vertical lightning bolt lets us know that Zeus has intervened here, and that Greek humanity will follow the way of the serpent's enlightenment.

It should not surprise us that Athena, who represents the rebirth of the serpent's Eve after the Flood, exercises confident authority as she tells Ares that it is not ordained for him to defeat Herakles. For this time in history, the way of Kain is destined to overpower the way of Seth.

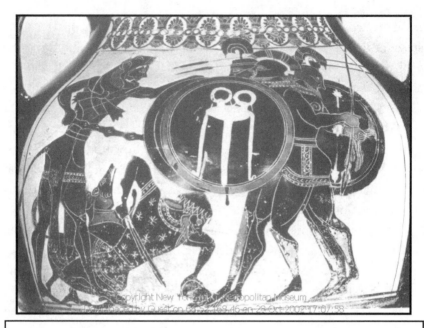

On this black figure amphora from ca. 550 BC, Herakles kills the dog, Orthos, his master, Eurytion, and moves forward to overpower the three-bodied Geryon, a picture of the three sons of Noah.

So far, in his march to the Garden of the Hesperides endeavoring to obtain the fruit of the serpent's enlightenment, Herakles has overcome Diomedes, a son of Ares, and Hippolyte, a daughter of Ares. He has then killed Ares' favorite son, Kyknos, and wounded Ares as well. These battles have taken place during the time of the rule of Noah's three sons, Shem, Ham, and Japheth. Now it is time for him, in his tenth labor, to overcome these three brothers, who, from the Greek viewpoint, represented the oppressive rule of the line of Seth.

Greek artists depicted the sons of Noah as a three-bodied man called Geryon, a name that relates directly to the patriarch. Except for the addition of one vowel in the center, it's the same as Geron, which means Old Man, a description repeatedly applied to Nereus, the Greek version of Noah.

Herakles' specific mission was to obtain the cattle of three-bodied Geryon. These cattle symbolized the wealth of Noah's three sons. Herak-

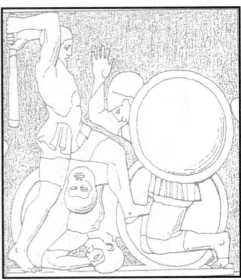

Above left: the fragmentary metope of Herakles killing the three-bodied Geryon from the east side of the temple of Zeus at Olympia, ca. 450 BC, and a restored drawing of it. The Greek hero has figuratively killed two of the sons of Noah, and is about to kill the third.

les took the cattle, and in the process killed a herdsman, his dog and the three-bodied Geryon. Historically, Herakles/Nimrod did not actually slay the three sons of Noah; this labor figuratively points to the fact that he overcame their authority. With their strange belief in an unseen God, the sons of Noah barricaded the road to humanity's progress. Armed with self-will and animosity for the line of Seth, Herakles, guided and protected by Athena, crushed the outward expression of what was to him a limiting and onerous spiritual viewpoint.

On the vase depiction opposite, Geryon's shield device is the same as Ares' on the Kyknos vase (page 154), a tripod. It is a prophetic symbol, and it means that with the power of Noah's sons vanquished, Herakles and his Greek religious system own the future for mankind.

Now, his supremacy unchallenged, in his final two labors, Herakles can bring back the serpent from the unseen realms, and enjoy the fruit of the serpent's tree unhindered.

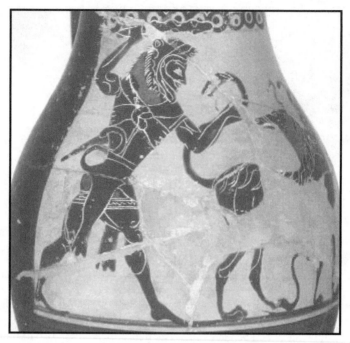

As his eleventh labor, Herakles brought Kerberos, the guardian of Hades, up to the light of day. Supposedly, Kerberos was a hound of two, or three, or fifty heads. The vase artists, however, made every effort to connect Kerberos to the serpent.

On the above vase from ca. 515 BC, for example, Herakles, in lion skin, is shown approaching Kerberos from behind and grasping his tail which ends in a bearded serpent's head. Two of the creature's feet end in lion claws, and two in serpents. Serpents appear on the creature's heads. Kerberos turns one of his heads towards Herakles while Hermes (not shown) grasps the snake forelock of his other head and prepares to throw a noose around him. Hermes/Cush and Herakles/Nimrod have captured the power of the serpent.

The ancient travel writer, Pausanias, summarily strips the creature of his superfluous dog heads and says that Kerberos was actually a serpent. He seems to take a skeptical pleasure in enumerating all the grottoes and crevasses where different Greek cities claimed Kerberos was hauled up by Herakles.

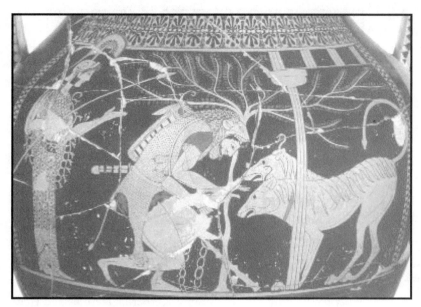

On this vase depiction from ca. 515 BC, Athena, holding her spear in one hand and wearing a larger-than-normal serpent-trimmed aegis, gestures with an opened palm towards Herakles as if say, "See, you don't have to worry about Kerberos. He won't hurt you." Herakles confidently approaches the two-headed creature who stands guard at the entrance to Hades, pictured here as a columned façade. The creature's upcurving tail ends in a snake head, and snake heads emerge from the dog heads.

Herakles approaches and appeases the dog, bending down as if to pet it with one hand, while holding a chain collar to subdue it with the other. Herakles has collared the serpent's power.

The literal meaning of Hades is "the unseen" or "the imperceptible." All the days of Noah after the Flood, and for a time under his three sons, the serpent's power was not to be seen. But then Herakles, making a passage of extraordinary daring, enters the very vestibule of death and re-emerges unscathed with the serpent's power in tow. By bringing the serpent out of the realm of the unseen up to the earth, Herakles makes the serpent's power manifest in human affairs. In reality, it's all happening at once. As Herakles' power grows, so does Athena's, so does Hermes', so does Zeus', and so does the serpent's power grow.

On the water pot above, from ca. 530 BC, Herakles holds the three-headed Kerberos by a leash as serpents coil from its heads and feet. On the plate below, from ca. 515 BC, Hermes accompanies Herakles, and appears visibly happy with the collaring of Kerberos. Hermes and Herakles are drawn as a father and son which, of course, they are: Cush and Nimrod.

Let me suggest a related meaning for this labor/myth. Even several centuries after the Flood, there must have been great fear of the consequences of embracing the serpent's wisdom. Could Herakles' message be that there is nothing to be afraid of, that he and Hermes have control of the serpent's power, and it will be used for the benefit of mankind?

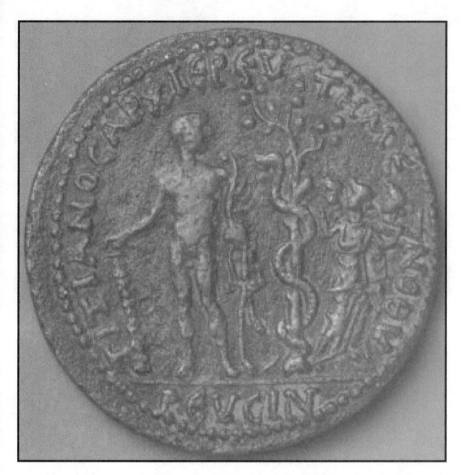

Above, the accomplishment of Herakles' final labor, the obtaining of the three golden apples from the serpent's tree in the Garden of the Hesperides, is celebrated on the reverse of a Roman coin from the 3rd century AD. We see Herakles (whose proportions are heroic), the apple tree, the serpent, and three Hesperides.

Feeling oppressed by the religious system of Noah, the Greeks sought a return to this garden, and the serpent's wisdom. Herakles, the Nimrod of Genesis, was the leader who made it possible. He overcame the rule of Noah's three sons, killed the sons and daughters of Ares/Seth, drove Ares off, brought back the serpent, and offered humanity open access to the fruit of the serpent's tree.

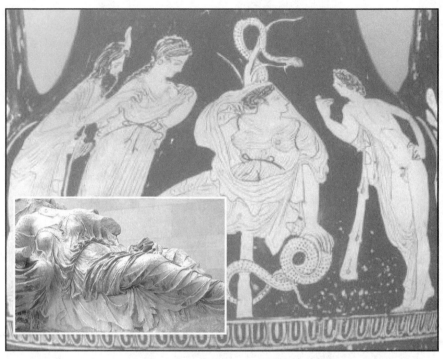

Above, we see the serpent, the tree, two Hesperides, Herakles to our right, and Hephaistos to our left. In Hephaistos, the deified Kain, we have the one who systematized belief in the serpent's wisdom before the Flood. In Herakles, the deified hero Nimrod, we have the man who, through force of arms, overcame the line of Seth after the Flood and, with the aid of Hermes and Athena, re-systematized belief in the serpent's wisdom.

An artist created the above vase-painting after the Parthenon sculptures were complete. For those who have read *Athena and Eden*, the lounging Hesperid in the center, resting her left hand comfortably on the serpent, should look very familiar. She looks very much like the lounging Hesperid, figure M, on the east pediment of the Parthenon (inset). Note the widely-spread breasts and the thin draw-string around the waist. It seems certain that the vase-artist based the central figure in his painting on Figure M, the lounging Hesperid on the Parthenon (See Chapter 8 of *Athena and Eden*).

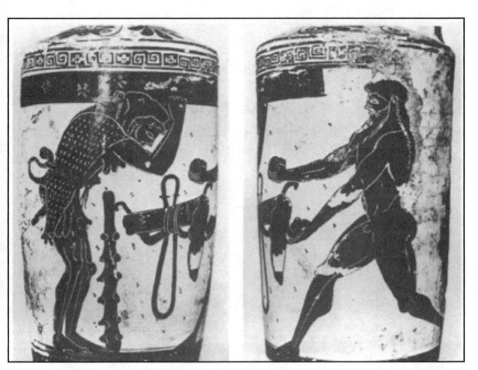

In Chapter 3, we saw that "wise Zeus" assigned Atlas to remain near the "clear-voiced Hesperides" and their garden, elevating the heavens. Atlas' objective in pushing away the heavens was to push away the God who inhabits these heavens. That was also the main objective of Herakles and those who idolized him. Feeling burdened and restricted by the religious system of Noah, the Greeks sought a return to the serpent's tree, and this meant that the authority of Noah's God had to be put at a great distance from them in order for Zeus-religion to succeed. Led by Hermes and Herakles (Cush and Nimrod) mankind easily moved toward what had been forbidden once in Eden and again during Noah's day.

On the above vase from ca. 500 BC, Herakles upholds the heavens while Atlas obtains the sacred fruit for him. After the Flood, Herakles repeated what Atlas had done originally in paradise. That is the simple meaning of the myth that Herakles upheld the heavens in Atlas' stead. Again and again, Greek myth proves itself to be a marvelous fusion of art and history.

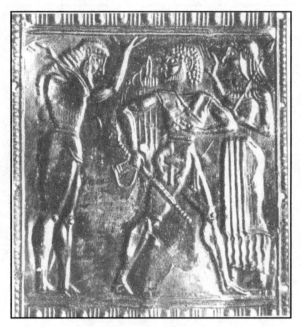

This bronze relief shield band panel from about 550 BC, features Atlas, Herakles, and Athena. Atlas, to the left, after giving the apples from the Garden of the Hesperides to Herakles, resumes upholding the heavens as Herakles moves off to the right toward Athena. It is now after the Flood, the God of the heavens has been removed to a great distance once again, and the apples belong with Athena, the reborn serpent's Eve.

Remember that Herakles' adventures, among other things, chronicle the transfer of power from Hera to Athena. The apples once belonged to Hera, as a picture of the original Eve. Now they belong to Athena, the new Eve of the Greek age. Athena is not the original connection to the serpent; Hera is. But the Flood wiped out that original connection along with the entire line of Kain. The serpent's Eve had to be reborn within the Greek framework. Athena's birth full-grown and fully-armed out of Zeus, pictured that rebirth perfectly.

Athena's receiving of the apples brought Herakles' labors to their proper end. Athena's rule over all of Greek society as the reborn serpent's Eve officially began when she received the golden apples from Atlas through Herakles who had subdued the Greek world on her behalf.

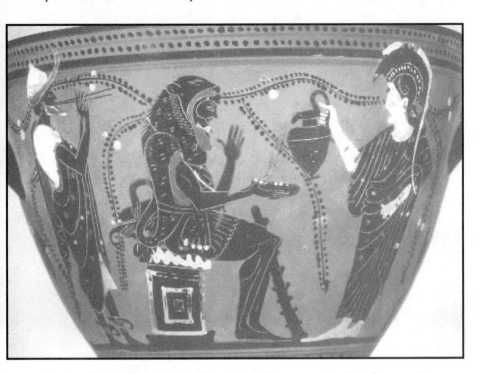

On the above drinking cup from ca. 500 BC, everybody's happy. Hermes and Athena regale Herakles who sits in a lion skin with his club between his knees. He raises his left hand in greeting and holds out a wine cup in his right hand toward Athena which she gladly fills. At the left, Hermes is playing flutes. Athena seems to be saying, "Great job, Herakles. Let me pour you a drink while Hermes plays your favorite song."

The time frame is either during Herakles' labors, and Hermes and Athena are rewarding and encouraging him because they know the final outcome; or he has completed his labors and is enjoying the soulish pleasures to which he is entitled.

These figures represent real people. Hermes and Herakles are, respectively, Cush and his son, Nimrod, from Genesis. They reorganized society on a commanding scale, reorienting humanity's spiritual outlook after the Flood. Athena represents Eve—the reborn serpent's Eve. Hermes and Herakles looked to her as their guiding spiritual force. As the operative wisdom and power of Zeus, the transfigured serpent, Athena established Hermes' theology, and provided the strength for Herakles in his labors.

Chapter 15
The Gods Defeat the Giants

The defeat of the Giants is the culminating event, the great cele-
bration, of ancient Greek religion. The rebellion of Hermes in Baby-
lon, the rebirth of the serpent's Eve, the replacement of Nereus with
Poseidon as god of the sea, the rebirth of the line of Kain in Athens,
and the labors and conquests of Herakles, all pertain to it or lead up
to it.

This is the fundamental assertion made by the ancient poets,
vase-artists, and sculptors: the Greek gods have defeated the Giants:
the Greek religious system has overcome the Yahweh-believing sons
of Noah.

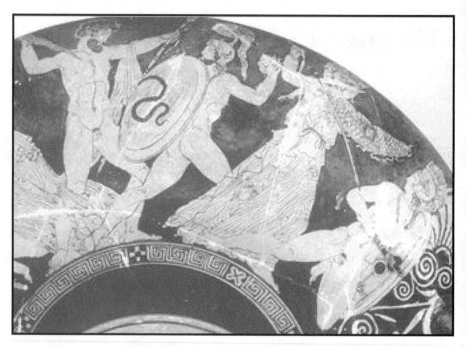

Above we see Zeus and Athena defeating the Giants on a cup from ca. 410 BC. On the opposite page, the Zeus portion of it is enlarged.

Zeus holds a lightning bolt in his raised right hand and his scepter in his left hand, as he prepares to kill the Giant, Porphyrion. Porphyrion flees to the right but turns to look back at Zeus as he prepares to throw a stone, a futile gesture. The artist is most likely engaging in irony, evoking the memory of the huge rock used to beat Kaineus into the ground. It is now a laughably smaller rock and worthless against the relentless onslaught of the gods.

Next to Zeus, Athena is about to spear the Giant, Enkelados. This Giant has fallen onto one knee. Athena has caught him by surprise: his shield is on the wrong side and his sword is still sheathed. Athena extends her left arm over him, and with it, her serpent-fringed aegis, or goat skin. Enkelados has turned his head toward Athena as she advances toward him, spear raised. He sees his own demise coming.

This is history. The way of Kain has overcome the way of Seth. Zeus-religion has overcome the Yahweh-believing sons of Noah.

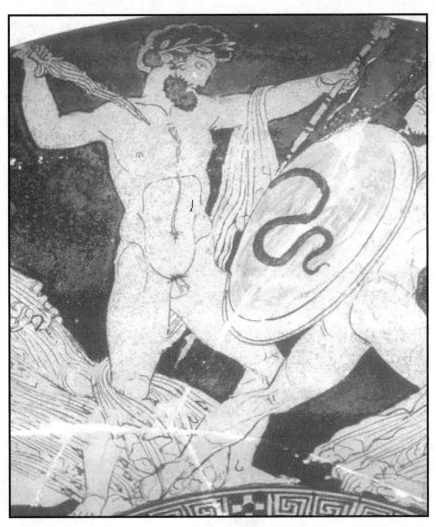

As we see in this enlargement of Zeus killing Porphyrion, the artist has provided four important symbols of the victory's significance. First, Zeus wears an olive leaf wreath, a symbol of the new age after the Flood; second, Zeus holds the lightning bolt, a symbol of the serpent's enlightenment; third, he holds the scepter of rule; and fourth, the serpent itself appears on the Giant's shield. The defeat of the Giants is about the rule of the serpent's enlightenment after the Flood. Or we could put it another way: this is the beginning of the transfigured serpent's enlightened rule.

Above, we see part of the east pediment from the old temple of Athena on the Akropolis, ca. 520 BC. Athena kills a Giant.

Below, on a water pot from ca. 480 BC, Athena and Zeus kill Giants. The Giant to the right falls with a huge rock above his head, probably an allusion to the rock the Kentaurs used to pound Kaineus into the ground before the Flood, but it is of no avail now. The Giant will wind up crushing himself with his own rock.

In many of these scenes, Athena is pictured as on this page, extending her aegis, which is a symbol of her authority. She is extending the authority of Zeus-religion over the Yahweh-believing sons of Noah.

The message on the partially damaged storage jar, above, from ca. 525 BC seems to be one of paybacks. Poseidon is about to pummel one of the Giants into the earth with a huge rock, in the same way that Kaineus (inset) was pummeled into the ground by the Kentaurs before the Flood. On many vases, Poseidon is pictured fighting Giants using his trident, so the rock must have special significance, and I think we know what it is.

Below, and on the page opposite, we see a total of six images from an Attic red figure lekythos (oil jug) from ca. 480 BC, now in the Cleveland Museum of Art. Curator Arielle P. Kozloff writes of it:

Here Douris [the Greek artist to whom the painting is attributed] portrays the death of the giant Enkelados at the hands of Athena in the legendary war between the gods and the giants. The artist has given us the most dramatic, most evanescent moment of this episode, and on this vase has rendered it timeless. Athena, intent on her prey, strides purposefully forward ready to give the coup de grace with her spear. This final blow is not necessary and this the goddess knows, for victory gleams in her eye . . . She has already wounded Enkelados; blood is pouring from his left thigh and rib cage. Douris has caught the giant just at the last excruciating moment before death as he reels backward, releasing his grip on his short sword, his eyes glazing over and turning skyward. Athena's emblem, the Gorgon head, appears to cheer her on with its open mouth just as the centaur [Kentaur] device on Enkelados' shield futilely enjoins the giant to keep up the battle. He shouts encouragement to Enkelados and lifts a barely visible branch as a replacement to the giant's fallen arms.

Let me add a few observations to Ms. Kozloff's insightful description. The Gorgon head represents the source of Athena's authority, "the head of serpents," and it is proclaiming victory as well as cheering on Athena. The branch held by the Kentaur is not a weapon but a symbol of that "strange branch" of humanity, the line of Seth, here soundly defeated by the line of Kain. It appears to me that the Kentaur is giving up.

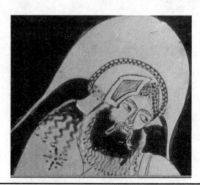

Blood streams from Enkelados' rib cage as his eyes glaze over.

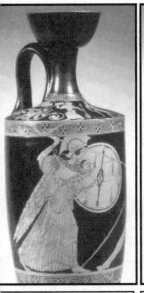

Athena.

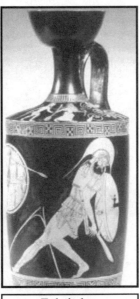

Enkelados.

Kentaur on Enkelados' shield.

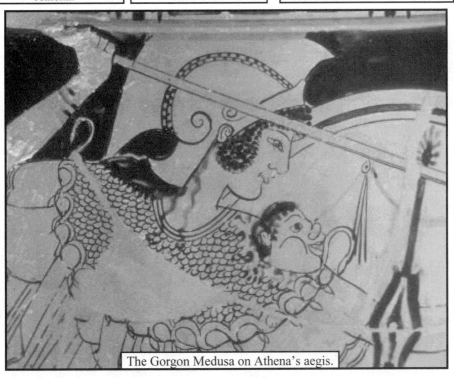

The Gorgon Medusa on Athena's aegis.

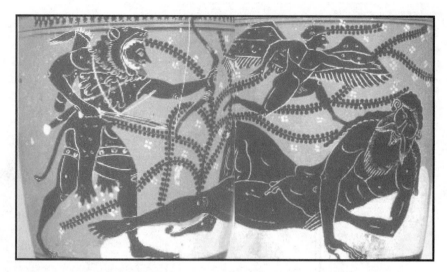

The language of Greek artists is universal. Above, from ca. 510 BC, Hypnos, the god of sleep, has put the Giant, Alkyoneus, to sleep as Herakles approaches. The spiritual transformation happened so quickly that Herakles caught the Yahweh-believing sons of Noah unawares.

Below from ca. 525 BC, a Giant kneels before Athena and Hermes. The artist seems to be telling us that it's the end of the old guard.

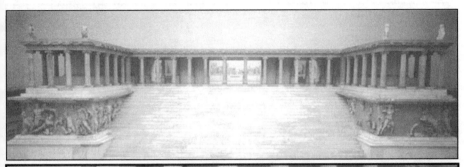

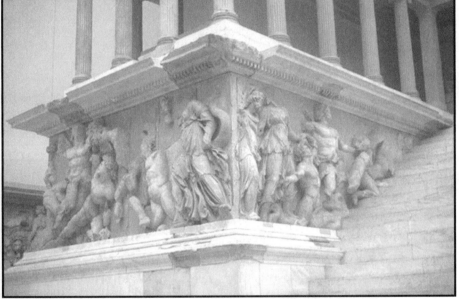

The Altar of Zeus at Pergamum as reconstructed in Berlin, and a close-up of some sculptures on the west side.

The Greek gods defeating the Giants was portrayed most vividly in the 120-meter-long frieze surrounding the great Altar of Zeus at Pergamum. Much of it survives and the entire altar with most of the sculpture has been reconstructed in the Pergamon* Museum in Berlin. The kings of Pergamum looked across the Aegean to Athens for their inspiration. For Pergamum as well as Athens, Athena was protectress of the city.

King Eumenes II ordered the great altar built as a tribute to both Zeus and Athena in 183 BC, and it was most likely completed in 178 BC.

*The city is variously referred to as Pergamum, Pergamon, and Pergamos.

Some scholars still describe this momentous action as "the *battle* between the gods and Giants" but as you see from the earlier images in this chapter, and those on the following pages, what is being portrayed here is the decisive *victory* of the Greek gods over the Giants—Zeus-religion over the Yahweh-believing sons of Noah.

The victory of the gods over the Giants wiped out belief in Noah's God throughout the ancient Greek world. Zeus-religion relegated the Supreme God of the Scriptures to the status of a non-entity, and elevated the serpent and humanity to the supreme heights. Overlooking their city, high atop a hill, pictured opposite, the Pergamenes built the Altar of Zeus, flagrantly boasting of the triumph of the serpent's system.

Since Jesus is the One Who said, "[W]hat is high among men is an abomination in the sight of God," it should not surprise us to find that He identified the Altar of Zeus with the rule of the Adversary or Satan. In Revelation 2:13, He speaks to His Jewish followers in Pergamum thus: "I am aware where you are dwelling—where the throne of Satan is." From a scriptural standpoint, the Altar of Zeus is the throne of Satan, the seat

The ancient site of the Altar of Zeus overlooking the city of Pergamum.

of the Adversary of God and His Christ.

When you understand what Zeus-religion really is—the line of Kain triumphant—many aspects of the spiritual history of humanity fit together like the pieces of a black-and-white jigsaw puzzle. The Greeks imagined that the crushing of the line of Kain during the Flood and the rebirth of the serpent's Eve as a virgin (Athena Parthenos) had put an end to the curse of Genesis. They were correct that there would be no "promised seed" to overcome the way of Kain coming out of Greece or other apostate nations. The promised Seed was to come out of the chosen nation, Israel, and be descended from Adam through Seth.

I look at the development of Zeus-religion as part of God's operations, for as Paul wrote in Ephesians 1:11, He is "the One Who is operating all in accord with the counsel of His will." Why didn't the Greeks have a clear perception of God? Paul explains that in Acts 14:16 writing that it was God "Who in bygone generations, leaves all the nations to go their ways." If Greece and other nations understood God and His purpose, Israel would not be His chosen people, and more to the point, without a deluded and lost humanity, there is no reason for a Savior.

The ancients entered the altar precinct from the east. Their first view was of Zeus and Athena—victors in the front rank of the battle which surged toward all sides. The image of Herakles does not survive but an inscription puts him to the left of Zeus. According to Pindar and others, the Giants could not be defeated without the help of the great hero who we know to be the Nimrod of Genesis transplanted to Greek soil.

Taking part in this great victory are all the chief Greek gods: Zeus, Athena, Nike, Hera, Herakles, Artemis, Apollo, Dionysos, Hephaistos, Ares, Poseidon, Aphrodite, and Hermes. The Altar of Zeus includes all of these, and it is so epically grandiose that it makes room for lesser deities such as the Three Fates, Amphitrite, Leto, Helios, Eos, Themis, Hekate, Nyx, and Selene to play a part in the utter routing of the Giants.

Above, from the north part of the frieze, Aphrodite, a deification of the wife of Kain, stomps on the head of an unfortunate Giant. Genesis 3:14 implies that the head of the serpent will eventually be crushed. The Greeks saw their gods as crushing the heads of the line of Seth.

Above, from the east frieze, Athena and the serpent bring down the winged Giant Enkelados. The wings are an indication of Enkelados' great spiritual power. A victory over beings with such a connection serves to emphasize the fearful and ultimate power of Athena and Zeus-religion.

Here is a man on the frieze that you may be able to identify because you have seen him on vases already. His face is solemn and sad, and he is the only figure on the entire frieze that is not actively engaged in the battle. From one of the corners, the sculptors have made him an observer of this horrendous defeat of the line of Seth.

This is Nereus, the Greek Noah. We've seen this same kind of theme on a vase where Nereus stoically observes the birth of Athena (the rebirth of the serpent's Eve), and on a vase where he stands by as Poseidon takes his daughter, Amphitrite, and Herakles wrestles away his power.

Next to Nereus stands his wife, Doris. I thought at first that she was actively engaged in subduing one of the Giants; that is, one of her own Yahweh-believing sons. Then I thought about the fact that the son's legs

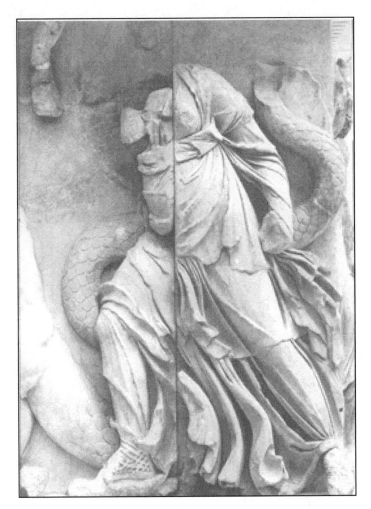

were turning into serpents. It is more likely that she is hopelessly trying to save a son who is figuratively turning to the serpent's system.

If Nereus and Doris were to look around the corner, their dismay would only increase; because there stands their daughter, Amphitrite, above, fighting on the side of the Greek gods, her exertions in that regard allied with the serpent's.

From the point view of Scripture, Noah and his wife are forced to witness "the abomination of desolation": faith in Yahweh ends, and humanity elevates and worships Zeus the transfigured serpent.

Chapter 16
Athena and Kain

Now the birth of the child on the cover illustration will begin to make sense. He is born from the sperm, or seed, of Hephaistos, placed into the soil of Athens by Athena herself.

Kaineus, the line of Kain, had been beaten into the ground by the line of Seth during the Flood. But in the Greek view, Kaineus was "invulnerable." The special child, Erichthonios, of the seed of Hephaistos, the deified Kain, springs to life out of the soil of Athens: the line of Kain is reborn, and the serpent's system, rejuvenated.

Before we analyze the meaning of the vase-painting, let's look in some detail at what is on it. The wonderful book, *Pandora: Women in Classical Greece*, edited by Ellen D. Reeder, features this vase and the following description of it:

[A]ll the figures are labeled except Gaia, Erichthonios, and the owl. Athena leans forward in left profile, her right foot on a rock. She wears a chiton [dress of lightweight fabric] beneath a peplos [a square wool garment, secured by a pin on each shoulder and worn open on one side or with a belt], as well as an aegis and a helmet rendered in checkerboard pattern; the helmet is crested. Gaia is seen in three-quarter right profile, rising out of the earth to her knees. She wears a belted peplos with overfold and a stephane [a bridal crown] over her long hair. Her right hand clasps Erichthonios' right thigh and the fingers of her left hand support his left side; he wears an amulet over his right shoulder and turns with both arms extended to Athena, whose hands are stretched out to him, her right hand touching the left side of his face.

Behind Athena a winged Nike strides forward, wearing a belted peplos with straps crossing her chest; over her left arm is a shield, and in her right hand is a spear. In front of her an owl is suspended frontally, a wreath in its claws. Beneath the Nike is Aphrodite, seated to her right and gazing at the central group. She holds a scepter in her left hand, and wears a belted peplos, a mantle over her lap, a sphendome [serpent-crown], a diadem, sakkos [a hair-covering in the form of a tasseled cap], earring, necklace, and bracelets. Behind her stands Zeus, with mantle and wreath, a thunderbolt in his left arm, a scepter in his right. [All we can see of Zeus in this view is the front of his body, and his right arm holding the scepter.]

Above Gaia's head, in a curve of landscape, is the upper torso of Hermes, who wears a petasos [traveling cap] and mantle and carries a caduceus [kerykeion, or staff with two facing serpent-heads on the end] in his right hand. Behind Gaia stands Hephaistos, who leans on a walking stick under his left arm. His right hand is on his hip; his left hand gesticulates, and he wears a decorated tunic and mantle, sandals, and a wreath. Behind him is Apollo [not shown], seated in three-quarter left profile, his head turned back in right profile. He wears a mantle draped over his waist and legs and a wreath over his long locks; his left hand steadies a laurel staff. Beside his right knee is a tripod on a column.

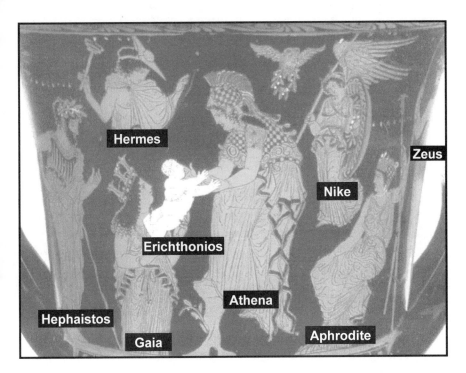

That description gives us an appreciation of the brilliance and intricacy of the vase-painting. We have arrived at the point where we can understand the cover illustration. The Flood wiped out the line of Kain. Only the line of Seth, through the family of Noah, survived. But yet the Greeks referred to the line of Kain as "invulnerable." If so, the line of Kain had to reemerge somehow. How did it happen? The answer is that Hephaistos, the deified Kain, sired a child.

The details are quite interesting. According to the ancient literary sources, Hephaistos pursued Athena on the Akropolis with sexual intent. The goddess wished to remain virginal and fought him off. Hephaistos ejaculated against her thigh, and Athena wiped it off with a piece of wool and placed the semen of Hephaistos into the earth. From it emerged the child Erichthonios (Earth-born One) who became the progenitor of the home-born kings of Athens.

Over time, the simple message of this myth has been obscured. The passionate sexual aggression of Hephaistos is not germane to the central

truth of the story. We are more likely, however, to remember a story with sex in it. And so this otherwise inexplicable lust of Hephaistos for the great virgin goddess of Athens is rather a framework which carries the story forward; and within that framework, we see the real meaning.

The simple and basic message of the myth is that the newborn child is the seed of Hephaistos, the deified Kain, who thus brings the line of Kain back into being in Athens.

I think that the sperm of Hephaistos touches Athena's thigh to show his true association with her. The two real people whom they represent are related "through the loins." Athena is a picture of Eve; Hephaistos, a picture of Kain.

The child, Erichthonios, became the Athenian ancestral king who fostered the worship of Athena. As a man, he set Athenian life in order and became know as Erechtheus, which signifies "Earth-born Placer." This idea of a man born from the earth echoes a truth expressed in Genesis. The popular King James Version tends to hide this through inexact translation. In it, Genesis 2:7 reads that God "formed man of the dust of the ground." The more accurate Concordant Literal rendering, matching the Hebrew, reads: "and forming is Yahweh Elohim the human of soil from the ground." According to the Scriptures, humanity is soil-born or earth-born. We are made of soil. All that nourishes us comes from it, directly or indirectly. The ancients understood this.

The Homeric *Hymn to Earth, Mother of All* begins:

I will sing of well-founded Earth, mother of all, eldest of all beings. She feeds all creatures that are in the world, all that go upon the goodly land, and all that are in the paths of the seas, and all that fly: all these are fed of her store.

And in a fragment, Solon wrote, "Great mother of the Olympian gods, dark Earth." Through the myth of Erichthonios, Zeus establishes the fact that he is able to produce the bodies of men from their actual source—the soil, or earth. He thus usurps the creative powers of Yahweh.

Remember that it was Kain who, according to the Book of Genesis, founded the first-ever city, naming it after his son, Enoch. After the

Flood, Kain reappears as part of the Greek pantheon, deified as Hephaistos; and with the loosing of his seed, he plays the crucial role in the founding of the city upon which the dominant culture of the world today is based. This time the city is named after Kain's mother, Athena, the deathless Eve who has been true to the serpent.

Let's get back to the vase. The artist has painted the child white to emphasize his purity and importance. Nike, her head cocked lovingly to the side, holds Athena's shield and spear, indicating that she is taking time out from battle, or possibly that the defeat of the Yahweh-believing sons of Noah is complete. Hephaistos wears an olive wreath; and the owl has an olive wreath for the child, as the olive tree is the symbol of the post-Flood age.

Aphrodite sits as if she were queen. As the wife of Hephaistos, she is entitled to revel in this great event.

As Hermes looks on the scene from above, he gestures as if conducting an orchestra. As the deified Cush of Babylon, he is the one who orchestrated the reestablishment of the way of Kain after the Flood. Behind Hephaistos, Apollo is out of the picture with his tripod. We've seen that the tripod from Apollo's oracle at Delphi is a symbol of the future. This child represents the future of Athens. Behind Aphrodite stands Zeus with his scepter suggesting that the child will partake of the god's rule. In his other hand, out of the picture, Zeus has his lightning bolt, representing his power and the moment of lighting up in paradise.

Kekrops, the half-man/half-serpent, does not appear on our vase, but he appears in many other "Birth of Erichthonios" scenes. He is the first non-earthborn king of Athens, and the child's step-father. On this coin from the Classical period, Kekrops stands over a large fish and holds an olive branch. The fish represents the great Flood, and as we know from the Book of Genesis, the olive branch is a sign of the new age that follows the Flood. The message: the new age belongs to the serpent's man.

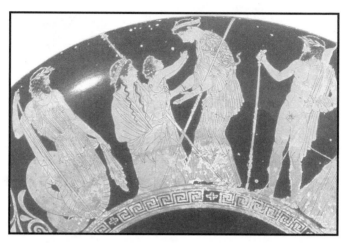

On the above vase-painting from ca. 430 BC, Kekrops and Hephaistos attend the birth of Erichthonios. We've seen that in the Book of Genesis, God condemned the serpent thus: "On your torso shall you go, and soil shall you eat all the days of your lives." The Greek religious system revered the serpent—it rose up and took the form of a man.

The painting, below, from ca. 440 BC, on a drinking cup from Athens, shows us Kekrops holding the scepter of kingship. In his other hand, he extends a ritual drinking bowl to Nike, who will fill it from a jug. That the serpent's man has brought the serpent's religious system to Athens is figured in this depiction as a great victory for the Greeks.

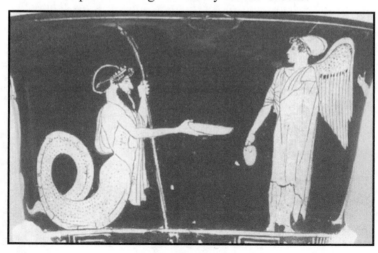

188

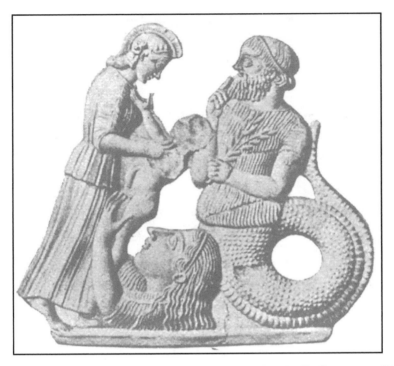

This terra-cotta scene from the Classical period tells the story of Kekrops and Erichthonios. Gaia (Earth), having been germinated by the seed of Hephaistos (the deified Kain), delivers up Erichthonios, the Earth-born child of all Athenians, to the care of his foster-mother Athena (the deified Eve). The olive branch in the left hand of Kekrops signifies the new beginning of the serpent's system after the Flood. His forefinger to his lips enjoins a silence at the birth of this holy child. Until the authority of Noah's sons was overcome, the rebirth of the line of Kain was kept secret.

The imagery of ancient Greek artists was profound, insightful, and revealing. Kekrops, the half-man/half-serpent, depicts so much more than simply the serpent's man. The artists have made Kekrops a symbol of the very foundation of Greek religion. In addition to portraying the first king of Athens, Kekrops represents a time in history—the beginning of the Greek religious system—when the serpent's enlightenment was in the process of becoming systematized as Zeus-religion.

189

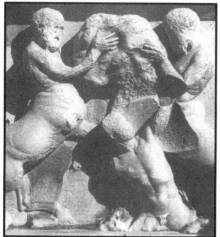
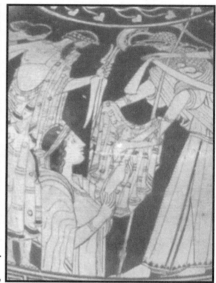

The Greeks understood the relationship between the two depictions, above. The major effect of the Flood was that the line of Seth (the Kentaurs) beat the line of Kain, or Kaineus, into the ground. But as the Greek legend says, Kaineus is invulnerable. With Athena's help and the seed of Hephaistos, Earth brings the line of Kain back into being after the Flood in the form of the child, Erichthonios, or Earth-born One, out of the same ground into which Kain was once beaten. Gaia, or Earth, presents the invulnerable, Earth-born One to Athena in the presence of Zeus, and the line of Kain is reestablished.

Below: the essence of ancient Greek religion is very simple. After the Flood, the reborn serpent's Eve . . . nurtures the reborn line of Kain.

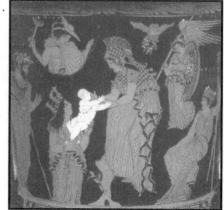

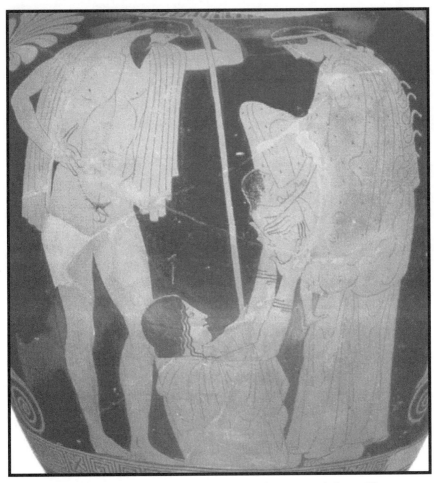

On the above vase from ca. 460 BC, Gaia, or Earth herself, presents the child to Athena, as the child's father, Hephaistos, the deified Kain, looks on as any proud father would. Gaia, wearing two serpent bracelets, lifts up the baby Erichthonios by his buttocks and left side, as he reaches out with his arms toward Athena. Athena's mantle is studded with stars. Note that the goddess has shifted her serpent-fringed aegis to her back so as not to frighten the child.

The birth of Erichthonios is a localized myth pertaining to the establishment of Zeus-religion in Athens. In the last chapter, we'll see how they celebrated the triumph of the serpent's system in the Peloponnesus.

Chapter 17
The Great Chariot Race—Hippodameia Avenged

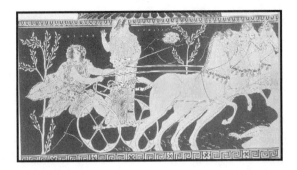

The east pediment of the temple of Zeus at Olympia depicted the preparation for the chariot race between Oenomaus and Pelops. It's a story of murder, deceit, attempted rape, and treachery. The fact that such a sordid tale was considered momentous enough to memorialize in marble on the temple of the supreme Greek god is puzzling—until we see that it chronicles the triumph of the way of Kain in the southern part of Greece known as the Peloponnesus.

Pelops, in Eastern dress, stands to our left of the altar and swears an oath with Oenomaus, who stands with his daughter, Hippodameia, opposite Pelops. If Pelops wins the chariot race to Corinth, he gets the girl. If Oenomaus catches him before the finish, he will kill his daughter's suitor.

The great and famous chariot race between Pelops and Oenomaus began at the altar of Zeus at Olympia. Here's how Apollodorus told the story:

> Now Oenomaus, the king of Pisa, had a daughter Hippodameia, and whether it was that he loved her, as some say, or that he was warned by an oracle that he must die by the man that married her, no man got her to wife; for her father could not persuade her to cohabit with him, and her suitors were put by him to death.
>
> For he had arms and horses given him by Ares, and he offered as a prize to the suitors the hand of his daughter, and each suitor was bound to take up Hippodameia on his own chariot and flee as far as the Isthmus of Corinth, and Oenomaus straightway pursued him, in full armor, and if he overtook him he slew him; but if the suitor were not overtaken, he was to have Hippodameia to wife. And in this way he slew many suitors, some say twelve; and he cut off the heads of the suitors and nailed them to his house.
>
> So Pelops also came a-wooing; and when Hippodameia saw his beauty, she conceived a passion for him, and persuaded Myrtilus, son of Hermes, to help him; for Myrtilus was charioteer to Oenomaus.
>
> Accordingly Myrtilus, being in love with her and wishing to gratify her,

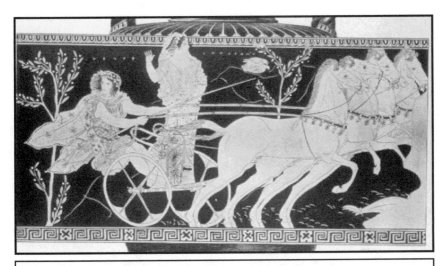

On this drawing of a vase-painting from ca. 410 BC, Pelops, who has come from Asia, races away with Hippodameia.

did not insert the linchpins in the boxes of the wheels, and thus caused Oenomaus to lose the race and to be entangled in the reins and dragged to death; but according to some, he was killed by Pelops. And in dying he cursed Myrtilus, whose treachery he had discovered, praying that he might perish by the hand of Pelops.

Pelops, therefore, got Hippodameia; and on his journey, in which he was accompanied by Myrtilus, he came to a certain place, and withdrew a little to fetch water for his wife, who was athirst; and in the meantime Myrtilus tried to rape her. But when Pelops learned that from her, he threw Myrtilus into the sea, called after him the Myrtoan Sea, at Cape Geraestus; and Myrtilus, as he was being thrown, uttered curses against the house of Pelops.

When Pelops had reached the Ocean and been cleansed by Hephaistos, he returned to Pisa in Elis and succeeded to the kingdom of Oenomaus, but not till he had subjugated what was formerly called Apia and Pelasgiotis, which he called after himself.

This is just another story with no religious significance unless we see through the veneer and focus on the references to Ares and Hephaistos. Oenomaus has chased down twelve suitors of his daughter, Hippodameia, with horses given to him by Ares, the Seth of Genesis. The

Above, the Peloponnesus. The chariot-race began at the altar of Zeus at Olympia and was to end at the altar of Poseidon on the isthmus of Corinth, a distance, as the crow flies over rugged terrain, of more than 100 kilometers.

travel writer, Pausanias, wrote of Oenomaus, "[P]oets proclaimed his father to be Ares, and the common report agrees with them." Another commentator adds that the armor of Oenomaus was a gift from Ares.

The meaning of Oenomaus' name also connects to Noah and the line of Seth, for it means "impetuous with wine," and such an episode involving Noah is recorded in the Book of Genesis. In fact, the only specific information we get about Noah's life after the Flood, other than his age and the names of his male offspring, is this story of his drunkenness and subsequent exposure in his tent (Genesis 9:20-27).

One the other hand, Pelops is identified with Hephaistos and the line of Kain. Pelops murders Myrtilus who had betrayed Oenomaus on his

Hippodameia and Pelops from the east pediment of the temple
of Zeus at Olympia, ca. 450 BC.

behalf, and this crime is cleansed by Hephaistos, the Kain of Genesis.
Pausanias makes clear the place of Pelops in the line of Kain writing,

**Of the gods, the people of Chaeroneia [a city in Asia Minor] honor most
the scepter which Homer says Hephaistos made for Zeus, Hermes received
from Zeus and gave to Pelops, Pelops left to Atreus, Atreus to Thyestes, and
Agamemnon had from Thyestes. This scepter, then, they worship, calling it
Spear. That there is something peculiarly divine about this scepter is most
clearly shown by the fame it brings to the Chaeroneans.**

This combination scepter and spear; that is, this weapon with author-
ity, comes from Hephaistos to Zeus to Hermes to Pelops. Pelops brings
the authority of Zeus by way of Hermes into the region ruled by Oe-
nomaus, conquering the king and the region on behalf of Zeus-religion.

Oenomaus and his wife Sterope, and the treacherous Myrtilus from the east pediment of the temple of Zeus at Olympia, ca. 450 BC.

Pausanias wrote that Myrtilus was buried behind a temple of Hermes, and that the local people sacrificed to him at night once a year, as to a hero. He may have betrayed Oenomaus because he lusted after Hippodameia, but the real reason Oenomaus couldn't trust his charioteer was that he was, according to Pausanias and Apollodorus, a son of Hermes.

Hippodameia abetted the murder of her father. Pelops swore an oath before the race, and violated it in the most foul way. Myrtilus betrayed his master unto death for the promise of sex with his daughter. Myrtilus abetted the treachery of Pelops, and received a fatal taste of Pelops' treachery himself. There is no redeeming *moral* to this story. There is an obvious *history* to the story, however. The sum of that history is this: the way of Kain overcame the way of Seth in the region of the Peloponnesus. That's why the beginning of the race is sculpted on Zeus' temple.

Let's consider the background of this localized story of the subjugation of the line of Seth by the line of Kain. After the Flood, Yahweh

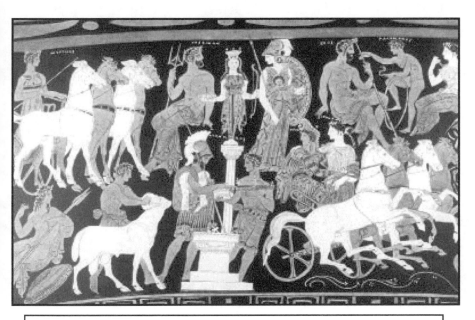

Above, on this drawing of a vase-painting from the Late Classical period, we see the preparations for the chariot race. Oenomaus and his chariot-driver stand at an altar, about to sacrifice a ram to Ares. Pelops, in elaborate oriental costume, prepares to take off in his chariot with Hippodameia after praying to Poseidon, who replaced Nereus/Noah as god of the sea.

commanded mankind to "be fruitful and increase, and roam in the earth and sway in it" (Genesis 9:7). Much of humanity, including the ancestors of Oenomaus, did so. Another group of humanity, seeking a different way, defied the Creator's instructions and massed together in Babylon for the sake of their own glory and power. With Cush (Hermes) as their leader, they said with pride in their self-sufficiency and independence from God, "Build will we for ourselves a city and a tower with its head in the heavens, and make for ourselves a name, lest we are scattering over the surface of the entire earth" (Genesis 11:4). When Yahweh confounded their speech into different languages at the Tower of Babel, they began to spread out, and they took their man-centered spiritual viewpoint with them.

On most vase paintings, the artists dress Pelops in Eastern garb because where he has come from is an essential element of the story.

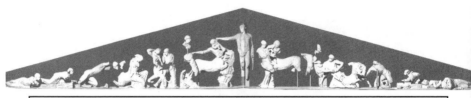

The west pediment of the temple of Zeus. "Hippodameia Abducted."

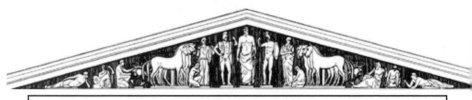

The east pediment of the temple of Zeus. "Hippodameia Avenged."

It is no coincidence that the name of Oenomaus' daughter is Hippo-dameia (Horse-tamer). As we have seen in Chapter 6, this was the name of Perithous' wife who, according to Greek legend, was abducted by Kentaurs (the line of Seth) before the Flood. And so the story of Pelops is not a simple one of conquest, but of vengeance as well, because, after the Flood, Pelops wrested back Hippodameia from the line of Seth, and their own women were theirs once more.

The west pediment of the temple of Zeus at Olympia depicted the Kentaurs taking the women from the line of Kain. A good title for it is "Hippodameia Abducted." In the center of the pediment stood Apollo, god of prophecy, with his right arm outstretched pointing to the future, a very specific future depicted on the other end of the temple. There, on the east pediment, the sculptors depicted the preliminaries of the chariot race that resulted in Pelops, of the line of Kain, seizing back Hippo-dameia from the line of Seth. A good title for the east pediment is "Hippodameia Avenged."

Pelops' taking of Hippodameia and killing her father, Oenomaus, was a profoundly religious act. The way of Kain had triumphed in the southern part of Greece. Another powerful son of Ares/Seth bit the dust. Pelops became one of most revered Greek heroes, and they called the Peloponnesus (Isle of Pelops) after him.

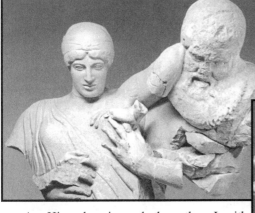

As Hippodameia and the other Lapith women are seized by Kentaurs, Apollo, god of prophecy, stands in the center of the west pediment pointing to the future portrayed on the east pediment. There, the sculptors portrayed the preliminaries of the great chariot race after the Flood which resulted in Pelops carrying off the beautiful Hippodameia in his chariot, pictured below, and in the death of her father, Oenomaus, of the line of Seth.

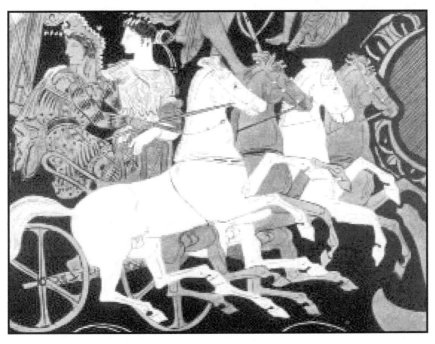

We have just deciphered the meaning of the pediments on the temple of Zeus at Olympia. This is something that has not been understood since before the time of the travel writer, Pausanias, who identified most of the figures in the 2nd century AD, but did not grasp the connection between the pediments.

The twelve metopes on the temple of Zeus, six on the east side and six on the west, depicted the twelve labors of Herakles. Now that you are acquainted with the historical realities that underlie the outward manifestations of Greek mythology and art, this should make perfect sense to you. While the east pediment boasted of the triumph of the way of Kain in the Peloponnesus after the Flood, the twelve metopes boasted of the triumph of Zeus-religion throughout the rest of the Greek world.

Inside the temple, elevated to a position of undisputed supremacy by the likes of Herakles and Pelops, the huge gold and ivory idol-image of Zeus sat enthroned. It was one of the seven wonders of the ancient world. How many millions then and since have cherished the huge fallacy that the great king of the Greek gods was something other than the ancient serpent from Eden transfigured into an image of the first man, Adam?

Epilogue

The ancient Greeks used their myths and their art to establish and proclaim their historical and religious identity. They viewed their myths as historical truths that had been communicated to them, and which they were determined to communicate to posterity.

To say that some ancient Greek myths tend to validate the early events described in the Book of Genesis is to greatly understate the case, even miss the point. The truth is that the entire formidable framework of ancient Greek society means virtually nothing without reference to those events.

The implications are far-reaching. This book is strong evidence, for example, against Darwin's evolutionary hypothesis. The Greeks knew where they came from, and it wasn't from tadpoles, monkeys, or knuckle-dragging troglodytes.

Why have these truths about the ancient Greek world been hidden from us for so long? I have some ideas on that, and will share them with you in the next book in the series, *Athena's Cloak*.

ART AND IMAGE CREDITS (Page Numbers in Bold Type)

26. *Adam and Eve* by Albrecht Dürer, etching. From Olga's Gallery (Web Site).
27. Wooden Zeus and Hera scanned from illus. 57, page 70 of *Greek Art* by John Boardman, fourth edition.
28. Masolino. *The Temptation of Adam.* 1424-25. Fresco. Brancacci Chapel, Santa Maria del Carmine, Florence, Italy. Olga's Gallery.
29. Zeus with Lightning Bolt. Berlin, Antikensammlung, F2293. Red figure cup. Provenance: Etruria, Vulci.
30. *Adam and Eve* by Tintoretto, ca. 1550. Oil on canvas, Gallerie dell'Accademia, Venice.
31. Hera and Zeus: Beazley archive.
32. Lekythos in the form of Sphinx, Hermitage Museum, St. Petersburg.
33. *Adam and Eve,* Hans Holbein, 1517. Oil on paper mounted on wood. Kunstmuseum Basel, Basel, Switzerland. Olga's Gallery.
33. Hera and Zeus from the east frieze of the Parthenon courtesy of the British Museum, London.
34. Massacio's fresco *Expulsion from the Garden of Eden* in the Brancacci Chapel, Florence, Italy. Image © Web Gallery of Art, created by Emil Kren and Daniel Marx.
34. Nike and Hera, Attic red figure, RISD 35.707. Photograph by Maria Daniels, courtesy of the Museum of Art, RISD, Providence, RI (Perseus Library).
35. Zeus, from Berlin F 2531. Photograph by Maria Daniels, courtesy of the Staatliche Museen zu Berlin, Preußischer Kulturbesitz; Antikensammlung.Attic red figure (Perseus Library).
35. Enthroned Hera, RISD 25.078. Photograph by Maria Daniels, courtesy of the Museum of Art, Rhode Island School of Design, Providence, RI (Perseus Library).

Chapter 3: Eden's Greek Counterpart

38. Victor Vasnetsov. *The Bliss of Paradise.* 1885-96. Fresco. Cathedral of St. Vladimir, Kiev, Ukraine. Olga's Gallery.
39. *Adam and Eve* by Lucas Cranach I.
40. Fragment from Beazley archive.
41. Hesperides Attic red figure hydria, London E224. Photograph courtesy of the Trustees of the British Museum, London (Perseus library).
42. Lutwin's *Temptation* from a German version of the *Vita of Adam & Eve.*
42. Inset from Hesperides at fountain, Attic red figure pyxis, London E 772, British Museum, London. Photograph by Maria Daniels, from Furtwängler & Reichhold, pl. 57, 2 (Perseus library).
43. Atlas, Herakles, and Athena: bronze relief, shield band panel, Basel, Antikenmuseum.
43. Atlas from a Laconian cylix, 6th century BC. Rome, Gregorian Etruscan Museum. Scanned from Plate VI in Carl Kerényi's *Prometheus.*

Chapter 4: The Way of Kain

46. Adam and Eve, Jacopo della Quercia, ca. 1428, Marble, height: 99 cm. S. Petronio, Bologna Web Gallery of Art.
47. *God Prefers Abel's Sacrifice,* Genesis Art Gallery Web Site.
50. Hephaistos and Thetis, Boston 13.188. From Caskey & Beazley, plate XLIV. With permission of the Museum of Fine Arts, Boston. Attic red figure nolan amphora.
50. Hephaistos on winged chariot, Cup by the Ambrosios Painter. Scanned from fig. 120, *ARFV The Archaic Period,* by Sir John Boardman. Berlin, Staatliche (East) 2273, from Vulci, ARV 174, 31
51. F. Fanelli's Drawing scanned from page 20 of B. F. Cook's *The Elgin Marbles.*
51, 52, 53. Jacques Carrey Drawings scanned from *The Parthenon and Its Impact on Modern Times* by Panayotis Tournikiotis, page 122.
54. Gustave Doré, Bible Illustrations c. 1866 *The Murder of Abel.*
55. Both vases from Beazley archive.
56. Return of Hephaistos, Attic red figure, Toledo 1982.88. Photograph by Maria Daniels, courtesy of the Toledo Museum of Art (Perseus Library).
57. Hephaistos return with bearded snake scanned from Sir John Boardman's *Athenian Black Figure Vases,* fig. 65.2
58. Hephaistos vase scanned from fig. 272, *Athenian Black Figure Vases,* by Sir John Boardman.

Chapter 5: Ares—The Hated Son of Zeus and Hera

61. Philadelphia MS3441; Side A: Ares, upper half. Photograph by Maria Daniels, courtesy of The

205

University Museum, Philadelphia. Attic black figure amphora.

63. Florence 4209: Aphrodite, Zeus, Hera, Athena, Ares (FR) Photograph by Maria Daniels, from Furthwängler & Reichhold, pl. 11 & 12. (Perseus Library).

64. Stamnos by the Achilles Painter. London E 448, from Vulci, ARV 992, scanned from fig. 115 in *Athenian Red Figure Vases: The Classical Period*, by Sir John Boardman.

Chapter 6: The Line of Seth Takes Kain's Women

66, 67. Parthenon south metopes 30 and 29. Photograph by Maria Daniels, courtesy of the Trustees of the British Museum, London.

68. Etruscan black figure neck amphora, Würzburg L 778, Martin von Wagner Museum, University of Würzburg. Photograph by Maria Daniels. (Perseus Library).

69, 70. Sculptures scanned from *Olympia: The Sculptures of the Temple of Zeus* by Bernard Ashmole and Nicholas Yalouris.

71. Attic red figure lekythos, Herakles and Perithous in Hades, Berlin inv. 30035, courtesy of the Staatliche Museen zu Berlin, Preußischer Kulturbesitz: Antikensammlung. Photograph by Maria Daniels.

72. Parthenon south metope 28. Photograph by Maria Daniels, courtesy of the Trustees of the British Museum, London. (Perseus Library).

73. Parthenon south metope 10. Photograph by Maria Daniels, courtesy of the Musée du Louvre, Paris.

74. Jacques Carrey Drawings scanned from *The Parthenon and Its Impact on Modern Times* by Panayotis Tournikiotis, page 123.

75. Bassae, near Phigaleia, temple of Apollo, east frieze. Detail of Lapith women beside the image of a goddess. British Museum, London.

76. Top, Munich 1428: Herakles fighting Nessos, Deianeira and Kentaur to right. Photograph copyright Staatl. Antikensammlungen und Glyptothek, München. Attic black figure Tyrrhenian amphora.

76. Bottom, Berlin F 1737: Herakles and Kentaurs. Photograph by Maria Daniels, courtesy of the Staatliche Museen zu Berlin, Preußischer Kulturbesitz: Antikensammlung. Attic black figure kantharos.

Chapter 7: The Flood Wipes Out the Line of Kain

78. Kaineus on the west frieze of the temple of Hephaistos scanned from fig. 114.7 in *Greek Sculpture: The Classical Period* by Sir John Boardman.

79. Beazley archive drawing of red figure stamnos in Musée du Louvre, Paris.

80. Kaineus. Florence 4209. Photograph by Maria Daniels. (Perseus Library).

81. *The Flood*, Michelangelo.

81. Kaineus: Malibu 86.AE.154: Attic Black Figure Siana Cup. Collection of the J. Paul Getty Museum, Malibu, California.

Chapter 8: Nereus—The Greek Noah

84. Nereus from Hartford 1961.8: Photograph courtesy of the Wadsworth Atheneum, Hartford, Connecticut. The Ella Gallup Sumner and Mary Catlin Sumner Collection. Attic black figure hydria.

85. Top, Malibu 77.AE.11: Nereus and fleeing Nereids. Collection of the J. Paul Getty Museum, Malibu, California. Attic red figure volute krater. (Perseus Library).

85. Bottom, Würzburg L 540: Side B: Nereus, detail of head and body. Photograph by Maria Daniels, courtesy of he Martin von Wagner Museum, Würzburg. Attic red figure, dinos and stand.

86. Harvard 1927.150: Triton. Photograph by Maria Daniels, courtesy of Harvard University Art Museums. Attic red figure neck amphora. (Perseus Library).

87. Top, Toledo 1982.134: Triton. Photograph by Maria Daniels, courtesy of the Toledo Museum of Art. Etruscan black figure hydria. (Perseus Library).

87. Bottom, Toledo 1956.69: Herakles and Triton. Photograph by Maria Daniels, courtesy of the Toledo Museum of Art. Attic black figure hydria. (Perseus Library).

88. Left, Malibu 87.AE.22: Herakles and Triton. Collection of the J. Paul Getty Museum, Malibu, California. Attic black figure zone cup.

88. Right, Hartford 1961.8: Shoulder: Herakles gripping Triton. Photograph courtesy of the Wadsworth Atheneum, Hartford, Connecticut. The Ella Gallup Sumner and Mary Catlin Sumner Collection. Attic black figure hydria. (Perseus Library).

89. Malibu 88.AE.24: Herakles fighting Kentaur. Collection of the J. Paul Getty Museum, Malibu, California. Attic black figure amphora. (Perseus Library).

90. Yale 1985.4.1: Photograph by Maria Daniels, courtesy of the Yale University Art Gallery, red figure kalyx krater. (Perseus Library).
91. Toledo 1956.58: Attic red figure stamnos. Photograph by Maria Daniels, courtesy of the Toledo Museum of Art.

Chapter 9: The Flood Depicted on the Parthenon

94. Reconstruction of the west pediment from the Internet.
95. Center of pediment from the Internet.
96, 97, 98. Jacques Carrey drawings scanned from figs. 46 and 47 in B. F. Cook's *The Elgin Marbles*.
99. Photograph of Iris courtesy of the Trustees of the British Museum, London.
100. Athena/Poseidon hydria scanned from page 454 of John Boardman's (et. al.) *The Art and Architecture of Ancient Greece*.
101. Poseidon hydria scanned from fig. 11 in Olga Palagia's *The Pediments of the Parthenon*. Pella Museum, Greece.

Chapter 10: The Transfigured Serpent

104. Serpent relief scanned from page 18 of Jane Ellen Harrison's *Prolegomena to the Study of Greek Religion*.
105. All three reliefs scanned from pages 19, 20, and 21 of Jane Ellen Harrison's *Prolegomena to the Study of Greek Religion*.
106. Serpent head scanned from illus. 16, east frieze section, in *The Great Altar at Pergamon* by Evamaria Schmidt.

Chapter 11: The Rebirth of the Serpent's Eve

108. Zeus, Athena, Hephaistos black figure: London B 424. Photograph courtesy of the Trustees of the British Museum, London (Perseus library).
109. Birth of Athena, black figure vase depiction, Boston 00.330, courtesy Museum of Fine Arts, Boston. H. L. Pierce Fund (Perseus library).
112. Birth of Athena: Louvre CA616, Attic black figure tripod kothon, Paris, Musée du Louvre. Photograph by Maria Daniels, courtesy of the Musée du Louvre. (Perseus Library).
113. Birth of Athena from Beazley archive.
114. Birth of Athena, black figure amphora, Beazley archive. Geneva, Musée d'Art et d'Histoire, MF154.
115. Birth of Athena, black figure amphora, Beazley archive.
116. Athena and serpent: Attic red figure stamnos, ca. 450 BC. St. Petersburg, State Hermitage Museum, B1559. Beazley Archive.
116. Athena with serpent crown is scanned from page 218 of John Boardman's *The Parthenon and Its Sculptures*.
118. Parthenon photograph courtesy of the Department of Archaeology, Boston University, Saul S. Weinberg Collection. (Perseus Library).
118. Dionysos killing Giant Attic red figure, Berlin F 2321. Berlin, Antikenmuseen. Photograph by Maria Daniels, courtesy of the Staatliche Museen zu Berlin, Preußischer Kulturbesitz: Antikensammlung (Perseus library).
119. *Athena Parthenos*, full-size reproduction in the Nashville Parthenon by Alan LeQuire (Parthenon.org).
120. Munich 2648: Tondo: Herakles and Athena. Photograph copyright Staatl. Antikensammlungen und Glyptothek, München. Attic red figure kylix.

Chapter 12: Hermes—The Deified Cush from Babylon

122. Tower of Babel from http://www.ldolphin.org/babel.html.
123. Hermes killing Argus: Red figure column krater. Oxford, Ashmolean Museum, England.
124. Hermes runs from Chiron Attic black figure amphora, Munich 1615A. Photograph copyright Staatl. Antikensammlungen und Glyptothek, München (Perseus library).
125. Hermes Elated from Beazley archive.
126. Herm scanned from page 29, and painting from page 57 of Peter Connolly's *The Ancient City*.
127. The Tower of Babel, by Gustav Doré 1866.

128. *Noah Releases Dove*: Frank Wesley, Indian Christian Artist.

129. Zeus and dove, photograph by Maria Daniels courtesy of Musée du Louvre, Attic red figure Nolan amphora.

129. Hermes with dove scanned from Athenian Red Figure Vases: The Archaic Period by Sir John Boardman, Figure 330. Berlin, Statliche Museen 2172, from Etruria, ARV 581, 4.

130. Mississippi: Iris and Hermes Photograph by Maria Daniels, courtesy of the University Museums, University of Mississippi. Attic. Red figure white ground lekythos.

130. Iris with little Hermes, red figure skyphos fragment. Tubingen, Eberhard-Karls-Univ., Arch. Inst., E106. Tubingen, Eberhard-Karls-Univ., Arch. Inst., 1600.

131. Harvard 1927.154. Attic Black Figure, white ground, oinochoe. Hermes killing a Giant. Photo by Maria Daniels, courtesy of Harvard University Art Museums.

Chapter 13: The First Seven Labors of Herakles

134. Seal and tripod images scanned from T. H. Carpenter's *Art and Myth in Ancient Greece*, figures 174, 175.

135. Vienna, Kunsthisstorisches Museum, Caeretan hydria, Herakles killing Egyptians. Photograph by Maria Daniels, from Furtwängler & Reichhold, p. 151.

136. Herakles strangling snakes, Attic red figure, Louvre G 192. Photograph by Maria Daniels, courtesy of the Musée du Louvre (Perseus library).

137. Herakles entering Olympus, Attic red figure, Villa Giulia 2382. Rome, Museo Nazionale di Villa Giulia. Photograph by Maria Daniels, from Furtwängler & Reichhold, pl. 20 (Perseus library).

138. Herakles and lion Attic red figure stamnos. Photograph by Maria Daniels courtesy of the University Museum, University of Pennsylvania.

139. Berlin F 2159: Herakles, upper half. Photograph by Maria Daniels, courtesy of the Staatliche Museen zu Berlin, Preussischer Kulturebesitz: Antikensammlung.

140. Mississippi 1977.3.62: Side A: Herakles and the Nemean Lion, with Athena and Hermes. Photograph by Maria Daniels, courtesy of the University Museums, University of Mississippi.

141. London B 193, Side B: Herakles and the Nemean Lion, with Athena at left and Iolaüs at right. Photograph courtesy of the Trustees of the British Museum, London. Attic bilingual belly amphora.

142. Hydra from Beazley archive.

143. Black figure lekythos, Herakles and the Hydra. Paris, Musée du Louvre, CA598.

144. Herakles and the Stymphalian birds. British Museum , London B 163, Attic black figure amphora. Photograph courtesy of the Trustees of the British Museum, London.

145. Stymphalian Birds metope, Temple of Zeus. Photographs by Maria Daniels, courtesy of the Greek Ministry of Culture, Olympia. Geryon Metope drawing © C. H. Smith 1990 (Perseus library).

146. Mississippi 1977.3.63: Side A: Herakles and the boar. Photograph by Maria Daniels, courtesy of the University Museums, University of Mississippi. Attic black figure neck amphora.

147, 148. Metope photos scanned from *Olympia: The Sculptures of the Temple of Zeus* by Bernard Ashmole and Nicholas Yalouris.

Chapter 14: Return to the Serpent's Tree—Herakles' Last Five Labors

150. Herakles and Nereus shield band panel scanned from figure 87 in T. H. Carpenter's *Art and Myth in Ancient Greece.*

151, 152. 153. Mississippi 1977.3.57: Herakles and three Amazons. Photograph by Maria Daniels, courtesy of the University Museums, University of Mississippi.

154. Herakles kills Kyknos. Lent by the Worcester Art Museum; Austin S. Garver Fund (1966.63). Broken and repaired; missing pieces restored and painted. Photograph by Maria Daniels, courtesy of the Worcester Art Museum, Worcester, MA.

156. Herakles and Geryon, New York (NY), Metropolitan Museum, 56.171.11. Black figure amphora, Beazley archive.

157. Metope photo and drawing scanned from *Olympia: The Sculptures of the Temple of Zeus* by Bernard Ashmole and Nicholas Yalouris.

158. Herakles and Kerberos, Worcester 1935.39 Photograph by Maria Daniels, courtesy of the Worcester Art Museum, Worcester, MA. Attic black figure olpe.

159. Louvre F 204: Herakles and Kerberos. Photograph by Maria Daniels, courtesy of the Musée du Louvre. Attic amphora.

160. Top: Herakles and Kerberos. Louvre E 701. Photograph by Maria Daniels, courtesy of the Musée du Louvre. Caeretan hydria. (Perseus Library).
160. Bottom: Museum of Fine Arts, Boston. Attic red figure plate. Tondo: Herakles, Hermes, and Kerberos. Boston 01.8028. From Caskey & Beazley, plate I. With permission of the Museum of Fine Arts, Boston.
161. Hesperides coin: reverse. Museum of Fine Arts, Boston. In memory of Zoë Wilbour.
162. Sculpture photo of Figure M courtesy of the British Museum, London.
162. Herakles and apple tree fragment, Beazley archive.
163. Herakles and Atlas white ground lekythos scanned from *Athenian Black Figure Vases* by Sir John Boardman, Figs. 252. 1, 2.
164. Bronze relief shield band panel scanned from fig. 210 in *Art and Myth in Ancient Greece* by T. H. Carpenter.
165. Mount Holyoke 1925.BS.II.3: Herakles regaled. Photograph by Maria Daniels, courtesy of the Mount Holyoke College Art Museum. Attic black figure skyphos. (Perseus Library).

Chapter 15: The Gods Defeat the Giants

168, 169. Zeus, from Berlin F 2531. Photograph by Maria Daniels, courtesy of the Staatliche Museen zu Berlin, Preußischer Kulturbesitz; Antikensammlung.Attic red figure (Perseus Library).
170. Athena kills a Giant image, courtesy Hellenic Ministry of Culture, Akropolis Museum Web Site.
170. Athena and Zeus, red figure hydria. London, British Museum, E165. Beazley archive.
171. Poseidon, black figure amphora. Beazley archive.
172, 173. Cleveland 78.59, Cleveland Museum of Art, Attic red figure lekythos. Athena killing Giant Enkelados. Photograph courtesy Cleveland Museum of Art.
174. Top: Toledo 1952.66: Alkyoneus and Sleep hovering. Attic black figure. Photograph by Maria Daniels, courtesy of the Toledo Museum of Art.
174. Bottom: Athena and Giant, black figure neck amphora. London, British Museum, 1926.6-28.7.
175, 178-81. Photographs of sculptures scanned from *The Great Altar at Pergamon* by Evamarie Schmidt.

Chapter 16: Athena and Kain

187. Kekrops Coin: Dewing 2176: obverse. Photograph by Maria Daniels, courtesy of the Dewing Greek Numismatic Foundation. (Perseus Library).
188. Top: red figure kylix with Kekrops. Berlin, Antikensammlung, Staatliche Museen zu Berlin Preussischer Kulturbesitz, inv. No. F 2537. Scanned from *Pandora*, page 259.
188. Bottom: rhyton. London, British Museum, inv. No. E788. Scanned from *Pandora*, page 45.
189. Terra cotta scene scanned from *Epilogomena to the Study of Greek Religion and Themis* by Jane Ellen Harrison, fig. 63.
190. Birth of Erichthonios: Attic red figure hydria scanned from page 254 of *Pandora*. London, British Museum, inv. No. GR1837.6-9.54 (E 182).
191. Birth of Erichthonios: Munich 2413, Munich Antikensammlunge, Attic red figure stamnos.

Chapter 17: The Great Chariot Race—Hippodameia Avenged

194. Pelops and Oenomaus. Detail from Apulian red figure vase. St. Petersburg State Hermitage Museum 4323 © State Hermitage Museum.
195. Hippodameia and Pelops. Photograph by Maria Daniels, from Furtwängler & Reichhold, pl. 67. Primary Citation: ARV2, 1157, 25; FR pl. 67. (Perseus Library).
197, 198, 201. Sculptures scanned from *Olympia: The Sculptures of the Temple of Zeus* by Bernard Ashmole and Nicholas Yalouris.
199. Chariot race scene, Attic red figure. Naples 2200, Naples, Museo Nazionale. Photograph by Maria Daniels, from Furtwängler & Reichhold, pl. 146. (Perseus Library).
200. Pediment reconstructions from *Olympia: The Sculptures of the Temple of Zeus* by Bernard Ashmole and Nicholas Yalouris.

Bibliography

Allan, Tony, ed., 1997. *Titans and Olympians: Greek and Roman Myth*. Time-Life Books BV, Amsterdam.

Ashmole, Bernard and Yalouris, Nicholas, 1967. *Olympia: the Sculptures of the Temple of Zeus*. Phaidon Press, London.

Ashmole, Bernard, 1972. *Architect and Sculpture in Classical Greece* (The Wrightsman Lectures), New York University Press.

Baring, Anne, and Cashford, Jules. 1991. *The Myth of the Goddess, Evolution of an Image*. Viking Arkana Penguin Books Ltd., London.

Beard, Mary, 2003. *The Parthenon*. Harvard University Press, Cambridge, Massachusetts.

Biers, William R., Second Ed. 1996. *The Archaeology of Greece*. Cornell University Press, Ithaca and London.

Boardman, John; Dörig, José; Fuchs, Werner; and Hirmer, Max, 1967. *The Art and Architecture of Ancient Greece*. Thames and Hudson, London.

Boardman, John, 1985. *Greek Sculpture: the Classical Period, a Handbook*. Thames and Hudson, Ltd., London.

Boardman, John, 1985. *The Parthenon and Its Sculpture*. University of Texas Press, Austin.

Boardman, John, 1985. *Athenian Red Figure Vases The Classical Period: a Handbook*. Thames and Hudson Ltd., London.

Boardman, John; Griffin, Jasper; and Murray, Oswyn, 1988. *Greece and the Hellenistic World*. Oxford University Press, Oxford, England.

Boardman, John, 1989. *Athenian Red Figure Vases: the Classical Period, a Handbook*. Thames and Hudson Ltd., London.

Boardman, John, 1996. *Greek Art*. Thames and Hudson, Ltd., London.

Boardman, John, 2000. *Athenian Red Figure Vases The Archaic Period: a Handbook*. Thames and Hudson Ltd., London.

Bothmer, Dietrich Von, 1957. *Amazons in Greek Art*. Oxford University Press, Oxford.

Bowra, C. M. and the Editors of Time-Life Books, 1965. *Classical Greece*. Time-Life Books, Alexandria Virginia.

Burckhardt, Jacob, 1998. *The Greeks and Greek Civilization*. St. Martin's Press, New York.

Burkert, Walter, 1983. *Homo Necans*. University of California Press, Berkeley and Los Angeles.

Camp, John M. 1986. *The Athenian Agora: Excavations in the Heart of Classical Athens*. Thames and Hudson, London.

Campbell, Joseph, 1964. *The Masks of God: Occidental Mythology*. The Viking Press, Inc., New York.

Carpenter, T. H., 1991. *Art and Myth in Ancient Greece*. Thames and Hudson, Ltd., London.

Castriota, David. 1992. *Myth, Ethos, and Actuality—Official Art in Fifth-Century B.C. Athens*. The University of Wisconsin Press.

Charbonneaux, Jean, 1972. *Classical Greek Art*. George Braziller, New York.

Connolly, Peter and Dodge, Hazel 1998. *The Ancient City: Life in Classical Athens and Rome*. Oxford University Press, Oxford and New York.

Cook, B. F., 1997. *The Elgin Marbles*. British Museum Press, London.

Crane, Gregory, ed., 2000, Compact Disc: Perseus 2.0 Platform Independent Version. *Interactive Sources and Studies on Ancient Greece*. Yale University Press, New Haven and London.

Dersin, Denise, ed., *What Life Was Like at the Dawn of Democracy*. Time-Life Books Virginia.

Donohue, A. A. 1988. *Xoana and the Origins of Greek Sculpture*. Scholars Press, Atlanta, Georgia.

Durando, Furio Stewart, 1997. *Ancient Greece: The Dawn of the Western World*. Tabori & Chang, New York.

Durant, Will, 1939. *The Life of Greece*. Simon and Schuster, New York.

Geldard, Richard G. 1989. *The Traveler's Key to Ancient Greece*. Alfred A. Knopf, New York.

Goldhill, Simon and Osborne, Robin, eds. 1994. *Art and Text in Ancient Greek Culture*. Cambridge University Press.

Grant, Michael, 1987. *The Rise of the Greeks*. Charles Scribner's Sons, New York.

Green, Peter, 1978. *The Parthenon*. Newsweek, New York.

Green, Peter, 1995. *Ancient Greece: A Concise History*. Thames and Hudson, Ltd., London.

Grene, David and Lattimore, Richard, eds., 1955. *The Complete Greek Tragedies, Volume III Euripides*, The University of Chicago Press, Chicago.

Hale, W. H., Ed. 1965. *The Horizon Book of Ancient Greece*. American Heritage Publishing Co., Inc., New York.

210

Harrison, Jane Ellen, 1962. *Epilegomena to the Study of Greek Religion and Themis*. University Books, New Hyde Park, New York.

Harrison, Jane Ellen, 1991. *Prolegomena to the Study of Greek Religion*. Princeton University Press, Princeton, New Jersey.

Hislop, Alexander, 1916. *The Two Babylons*, Loizeaux Brothers, Neptune, New Jersey.

Hornblower, Simon and Spawforth, Anthony, eds., 1998. *The Oxford Companion to Classical Civilization*. Oxford University Press, Oxford / New York.

Jeppesen, Kristian K., 1982. "Evidence for the Restoration of the East Pediment Reconsidered in the Light of Recent Achievements." *Parthenon Kongress*, Basel.

Kerenyi, C., 1951. *The Gods of the Greeks*. Thames and Hudson, New York.

Kerenyi, C., 1963. *Prometheus: Archtypal Image of Human Existence*. Pantheon Books, Random House, Inc. New York.

Kerenyi, C., 1976. *Dionysos*. Bollinger Series 2, Princeton University Press, Princeton, New Jersey.

Kerenyi, C., 1975. *Zeus and Hera*. Princeton University Press, Princeton, New Jersey.

Kokkinou, Sophia, 1989. *Greek Mythology*. Sophia Kokkinou, Athens.

Lagerlöf, Margaretha Rossholm, 2000. *The Sculptures of the Parthenon: Aesthetics and Interpretation*. Yale University Press, New Haven and London.

Lefkowitz, Mary R., 1990. *Women in Greek Myth*. The Johns Hopkins University Press, Baltimore.

Morford, Mark P. O. and Lenardon, Robert J. 1971. *Classical Mythology*. David McKay Company, Inc., New York.

Neils, Jenifer, 2001. Cambridge University Press, United Kingdom.

Neils, Jenifer., Ed. 1996. *Panathenaia & Parthenon*. The University of Wisconsin Press.

Palagia, Olga, 1993. *The Pediments of the Parthenon*. E. J. Brill, New York.

Parada, Carlos, 1993. *Genealogical Guide to Greek Mythology*. Paul Astroms Forlag, Jonsered, Sweden.

Parke, H. W. 1977. *Festivals of the Athenians*. Cornell University Press, Ithaca, New York.

Parker, Robert 1996. *Athenian Religion: A History*. Clarendon Press, Oxford, England.

Pinsent, John, 1969. *Greek Mythology*. Peter Bedrick Books, New York.

Pollit, J. J., 1972. *Art and Experience in Classical Greece*. Cambridge University Press, London.

Reeder, Ellen D., Ed. 1995. *Pandora: Women in Classical Greece*. Princeton University Press, Princeton, New Jersey.

Rodenbeck, Christina, ed., 1998. *Triumph of the Hero: Greek and Roman Myth*. Time-Life Books BV, Amsterdam.

Rodocanachi, C. P., 1951. *Athens and the Greek Miracle*. The Beacon Press, Boston.

Schmidt, Evamaria. 1965. *The Great Altar at Pergamon*. Boston Book and Art Shop, Inc., Boston.

Schefold, Karl, 1967. *The Art of Classical Greece*. Greystone Press, New York.

Smith, R. R., 1991. *Hellenistic Sculpture*. Thames and Hudson, Ltd., London.

Spivey, Nigel, 1997. *Understanding Greek Sculpture*. Thames and Hudson, Ltd., London.

Stewart, J. A. 1970 (1905 Reprint). *The Myths of Plato*. Barnes and Noble, Inc.

Stokstad, Marilyn, 1995. *Art History*. Harry N. Abrams, Inc., New York.

Stone, I. F., 1988. *The Trial of Socrates*. Anchor Books, Doubleday, New York.

Toorn, Karel van der and Becking, Bob and Horst, Pieter W. van der, eds. 1999. *Dictionary of Deities and Demons in the Bible*. William B. Eerdmans Publishing Company, Grand Rapids, MI / Cambridge, U. K.

Tripp, Edward 1970. *The Meridian Handbook of Classical Mythology*. New American Library, New York.

Tyrrell, Wm. Blake. 1984. *Amazons: A Study in Athenian Mythmaking*. The Johns Hopkins University Press, Baltimore and London.

Walker, Barbara G. 1983. *The Woman's Encyclopedia of Myths and Secrets*. Harper & Row Publishers, San Francisco.

Ward, Anne G. 1970. *The Quest for Theseus*. Praeger Publishers, Inc. New York.

West, John Anthony 1988. *Serpent in the Sky: The High Wisdom of Ancient Egypt*. Quest Books, Theological Publishing House, Wheaton, Illinois.

Wilde, Lyn Webster, 2000. *On the Trail of the Women Warriors: The Amazons in Myth and History*. Thomas Dunne Books, St. Martin's Press, New York.

211

Index